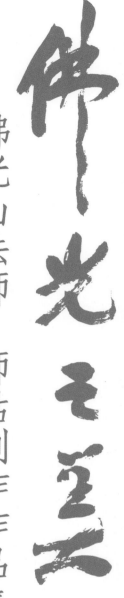

佛光之美

佛光山法師、師姑創作作品集
2017-2021
————

Beauty of
Buddha's Light

Art by Members of Fo Guang Shan
Monastic Order 2017-2021

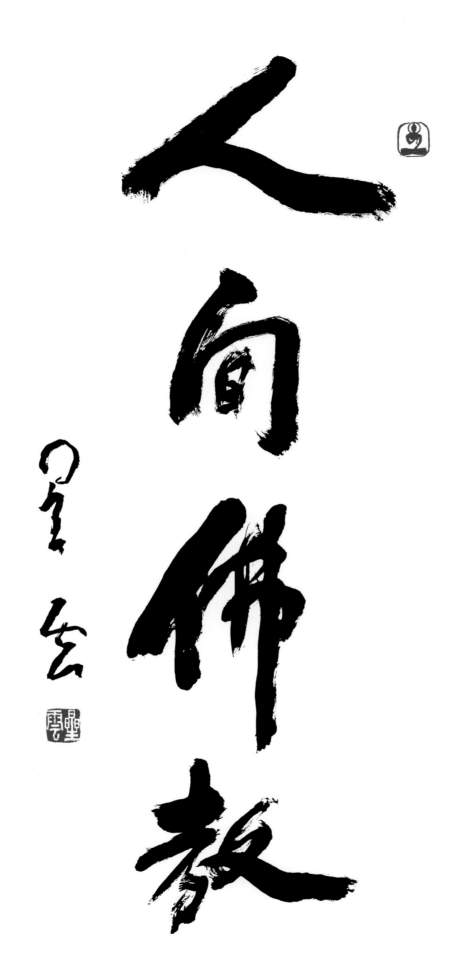

人間佛教

Ren Jian Fo Jiao

Humanistic Buddhism

What the Buddha taught,
What humans need,
What is purified,
What is virtuous and beautiful.

137.4 x 68.9cm

人間佛教

佛說的、人要的、淨化的、善美的。

目次

Table of contents

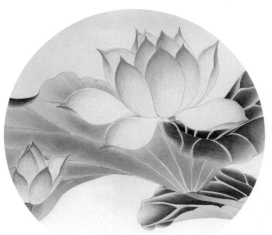

《佛光之美》畫冊序

在中國傳統文化中，很多都與佛教有甚深的關聯，如語言、飲食，乃至書畫藝術等，甚至許多僧人也是書畫名家，從唐朝懷素、貫休，至清初更有四僧名家：弘仁（江韜）、髡殘（石谿）、八大山人（朱耷）、原濟（石濤），乃至近代弘一等等，這些歷代高僧作品至今仍為世人所景仰。

所謂「道藝一體」，僧人的修行與書藝並不相違，甚至文化藝術更有助於佛教之弘化！最具代表者當屬家師——星雲大師。「星雲大師一筆字書法展」至今在全球超過25個國家展出逾170場次，因此而接觸了佛教、信仰了佛教，乃至因為佛法而得到喜悦的人，實在難以計數。

星雲大師相當重視文化，甚至表示如果寺廟裡連一張勸人向善的字畫都沒有，這寺廟沒有文化。大師以敦煌石窟的概念蓋了佛光山的殿堂，佛光山很多的

建築物，室內牆壁也都掛了字畫。受師父的影響，弟子們所負責的道場也是如此。

大師不僅自己寫書法，也鼓勵徒眾發揮所長從事創作，還為此每年舉辦「佛光山徒眾作品聯展」，我想這不僅是佛教界的創舉，對於佛法的生活化更有著潛移默化之功。「以文化弘揚佛法」是大師大化於無形的般若智慧，也是人間佛教的具體實踐。

今年在佛光緣美術館總館長如常法師的用心規劃下，不僅將徒眾作品舉辦全球巡迴展，同時將前五年優選以上作品集結出版《佛光之美—佛光山法師、師姑創作作品集》，為當今人間佛教留下文獻。感謝所有徒眾的集體創作，謹以此共勉，是為序！

佛光山住持

心保

Beauty of Buddha's Light
Album Preface

In traditional Chinese culture, many of them are deeply related to Buddhism, from language and diet to painting and calligraphy. Many monks are also famous painting and calligraphy artists. Examples include: Monk Huai Su and Guan Xiu of the Tang Dynasty to the early Qing Dynasty, there were four famous monks: Hong Ren (Chiang Tao), Kun Chan (Shi Xi), Bada Shanren (Chu Da), Yuan Ji (Shi Tao). Venerable Hong Yi is a representation of the modern times. The works of these eminent monks from past dynasties have retained timeless admirations from people around the world.

The so-called "Unification of Bodhi and Arts" resonates the suggestion that the practice of monks do not depart from calligraphy. Culture and art are in effect very helpful in the propagation of Buddhism! The most notable representation of this concept is certainly our Master, Venerable Master Hsing Yun. "Venerable Master Hsing Yun's One-Stroke Calligraphy Exhibition" has been exhibited over 170 times in more than 25 countries around the world. As a result, it is difficult to count the number of people who became in touch with Buddhism, believe in Buddhism, and even gain Dharma joy because of Master Hsing Yun's artistic works.

The Master deeply values culture, and if there is no calligraphy or painting in the temple

to encourage people to be good, then the temple has no culture. The Master constructed Fo Guang Shan from the concept of Dunhuang Caves. Many buildings in Fo Guang Shan have calligraphy and paintings on the indoor walls. Under the influence of the Master, the disciples follow the same in their own branches respectively.

The Master not only writes calligraphy himself; he also encourages his disciples to use their talents creatively. For this reason, the "FGS Monastic Art Exhibition" has been held every year. I believe the art exhibitions have not only served as a pioneering undertaking in Buddhism; it also had an imperceptible influence on the promotion of Humanistic Buddhism. "Promoting Buddhism through Culture" is a formless Prajna wisdom of the Master's fundamental instrument in putting Humanistic Buddhism into the practice.

This year, under the curator of the Fo Guang Yuan Art Gallery and Venerable Ru Chang's elaborate planning, the disciples' works will hold a touring exhibition globally. At the same time, selected works from the past five years will be published in "The Beauty of Buddha's Light: Art by Members of Fo Guang Shan Monastic Order 2017-2020" as documentation of today's Humanistic Buddhism. Thanks to all the disciples for their collective works, and continue to inspire each other as this preface!

Most Venerable Hsin Bau | Abbot of Fo Guang Shan Monastery

人間佛教之美

徒眾作品聯展的創意來自星雲大師的構想與對弟子的鼓勵，希望徒眾在弘法之餘也能培養自己的興趣，為此大師慎重其事地幫弟子們舉辦畫展。首次展出是2011年的「菩提會藝」，在佛光山年度舉辦的徒眾講習會現場展出，由徒眾投票選出各類前三名並發給獎金，2013年以相同形式舉辦「海會雲來集」聯展。二次也分別到海內外的佛光緣美術館舉辦展出，內容以書畫類為多。

2017年開始，「佛光山徒眾作品聯展」成為佛光山年度常態展出。為鼓勵與提升徒眾的創作技能，大師指導由佛光緣美術館總部聘請外部專業審查委員舉辦徵件作品審查會選出各類獎項，通過後便在佛光緣美術館舉辦展覽，至今已連續舉辦五年。從一開始的書畫，慢慢發展成目前繪畫、書法金石、立體、攝影、影音等五大類。

剛開始，即便徒眾還不清楚怎麼樣做創作，但第一年就有100人投了220件作品；到了2020年竟然有230多人參加，收到近600件創作，令人感到意外。平常大家法務其實都很繁忙，還願意撥時間發心創作，實在令人感到欣慰！顯然大家也越做越有心得，也做出興趣來了。不僅如此，在經費有限下，一些創作材料都是來自環保回收再利用，或是以身邊容易取得的素材來創作，但作品內容從傳統到當代，兼具生活性、藝術性、教育性與觀賞性，非常精彩，甚至有一些作品已經達到藝術創作的內涵，連評審的專業委員都讚嘆不已！

每年的徒眾聯展都令觀賞者感到非常歡喜，很多人看完展覽後紛紛簽名留言，

表示佛光山人才濟濟、臥虎藏龍、法師十八般武藝樣樣俱全……等等，而更多人因為展出，才真正體會到星雲大師的人間佛教是如此的活潑，如此深具人間性格。

佛光山是星雲大師所開創的人間佛教道場。甚麼是「人間佛教」？大師表示人間佛教就是「佛說的、人要的、淨化的、善美的」。從展出中我們不難發現，徒眾的作品充份展現出人間佛教的特質，而「佛光之美」就是人間佛教之美！

這次負責美術館的如常法師要為徒眾出版畫冊作為紀念，我也以這篇序祝福大家！

佛光山傳燈會會長

慈容

The Beauty of Humanistic Buddhism

The creativity of the "FGS Monastic Art Exhibition" comes from Venerable Master Hsing Yun's idea and his encouragement to the disciples to cultivate their own interests while promoting Buddhism. For this purpose, Venerable Master Hsing Yun carefully organizes exhibitions for his disciples. The first exhibition of "Bodhi VS Art" was held in 2011 at the annual Monastic Seminar in Fo Guang Shan. The winners were voted by disciples and the top three winners of every category were given monetary prizes. In 2013, the "Monastics Great Gathering" exhibition was held in the same format as the first one. The two exhibitions were held both domestic and overseas, and the contents of the exhibitions were mostly in the form of paintings and calligraphies.

"FGS Monastic Art Exhibition" became a regular exhibition held annually since 2017. To encourage and improve disciples' creativity, guided by Venerable Master Hsing Yun, the Headquarter of Fo Guang Yuan Art Gallery hired a professional judging committee to select the winners of various awards. The winners' works were then exhibited in the Fo Guang Yuan Art Gallery Headquarter. In the beginning, most works were in the form of calligraphy and painting. Then, it gradually developed into five categories of contemporary painting, calligraphy and epigraphy, three-dimensional art, photography, digital media, etc.

At the beginning, even though the disciples had little know-how of creative art, 100 participants submitted 220 artworks in the first year. In 2020, by surprise, participation surpassed 230 people with over 600 artwork submissions received. Normally, everyone is very busy with Dharma services, so it is really gratifying to know that they were still willing to devote time into creative art. It is apparent that everyone has become more and more knowledgeable and interested in art. Not only that, with limited funding, some creative materials came from recycled materials in the environment or materials that were readily available around us. Despite some limitations, the contents of submitted artworks ranged widely from traditional to contemporary in the demonstration of daily life, art, education and leisure. Very exciting, indeed! Some of the artworks have already mastered the connotation of professional artistic creations where even the panels of expert judges were amazed!

Each year's exhibition makes the viewers feel joyful. Many viewers have left comments referring Fo Guang Shan as is a place of many talented individuals in disguise, and how the venerables are actually very skillful all around. Because of the exhibitions, more people became deeply aware of Venerable Master Hsing Yun's Humanistic Buddhism being so lively and close to humanity.

Fo Guang Shan is a place of Humanistic Buddhism founded by Venerable Master Hsing Yun. What is "Humanistic Buddhism"? To Venerable Master, it is "Buddha's teaching, human's needs, all that is purified, virtuous and beautiful." From the exhibitions, it is not difficult to discover that the works of the disciples are perfect demonstrations of Humanistic Buddhism, and the "Beauty of Buddha's Light" is the beauty of Humanistic Buddhism!

In commemoration of this event, Venerable Ru Chang, the Curator of the art gallery, will publish a picture album for the disciples. With this preface, I want to extend my best wishes to you all!

Venerable Tzu Jung | Executive Director, Sangha Affairs Committee

看見佛光之美

佛光緣美術館成立近三十年，除自行策畫總本山重要展出，以及國內外館際與文化團體的交流展外，多數是為藝術家舉辦展覽。佛光山徒眾作品聯展是相當特殊的展出，對象既非藝術家也不是文化團體，而是以出家人為主的僧團，展出的內容當然也不是所謂的藝術品。這充滿創意的展出，背後真正的策展人正是佛光山開山——星雲大師。

大師是如何重視這個展覽？大師指導要有徵件辦法、找專業審查委員進行審查，由委員決定得獎作品、要在美術館展出、舉辦開幕式及頒獎典禮，大師更提供獎金鼓勵徒眾創作，期許大家在弘法之餘，以文化藝術淨化人心。於是我們除安排佛光緣美術館分館主任外，還特別邀請洪根深、黃壬來、蘇志徹、陳明輝、楊文霓等專為臺灣各大美術館擔任審查委員的大學教授來為我們做評審。

究竟教授們會如何評徒眾的作品，剛開始確實令人感到忐忑。然出乎意料的，歷屆委員對作品均給予相當的好評，甚至提供許多建議與指導。洪根深教授表示法師能運用線雕結合光影成為裝置藝術，作品非常有創意，許多攝影作品，已隱含弘法、修持與悟道的內涵；黃壬來教授則訝異於作品的水平超乎他所預期，前幾名作品都是原創，無論是創意、技法、構圖都令人讚賞。委員們對於大師為徒眾舉辦展覽，以文化弘揚佛法的理念與深義均感敬佩。

「佛光山徒眾作品聯展」是佛教界的創舉。為讓更多人看到這些作品特別收錄2017-2021年優選以上作品編纂這本畫冊出版，同時也為佛教留下文獻紀錄。

佛光緣美術館總館長

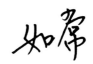

Seeing the Beauty of Buddha's Light

Fo Guang Yuan Art Gallery has been established for nearly 30 years. In addition to planning major exhibitions at the main temple of FGS, as well as exchange exhibitions between domestic and overseas libraries and cultural groups, most of the exhibitions were held for artists. "FGS Monastic Art Exhibition" is a very special exhibition. The exhibitors are neither artists or cultural groups. They are venerables from the Buddhist monastic community. Consequently, the contents of exhibited works are not necessary just works of art. The curator behind this creative exhibition is the founder of Fo Guang Shan — Venerable Master Hsing Yun.

How does the Venerable Master show his high regard for this exhibition? The Venerable Master advised us on the method of soliciting artwork submissions, and made sure each submitted artwork is censored by a professional committee. He suggested that the committee will then decide on the winning artworks and which ones are to be exhibited at the art exhibition. The art exhibition will have an opening and award ceremony. Therefore, we decided to invite Hong Gen-shen, Huang Ren-lai, Su Zhi-zhe, Chen Ming-huei, Yang Wen-ni and other university professors who served as review committees for major art museums in Taiwan to help with the judging process. How these professors would comment on the artworks of the disciples was really nerve-racking at beginning. Unexpectedly, the judges gave considerable praises to all the submitted artworks, and even provided many suggestions and guidance. They expressed admiration for the concept and profound meaning behind the master's art exhibition for his disciples.

"**FGS Monastic Art Exhibition**" is a pioneering advancement in Buddhism. This album was especially compiled and published to enable more people to view these artworks. At the same time, it served as a monumental documentary of a groundbreaking movement in Buddhism.

Venerable Ru Chang | Director, Fo Guang Yuan Art Gallery Headquarters

歷年邀請展

*Invitational Exhibitions
over the Years*

以師志為已志
以佛心為已心

To Treat Master's Aspirations as My Own Aspiration
To Treat Buddha's Mind as My Own Mind

心定和尚｜臺灣／HSIN TING｜Taiwan

● 2021 **邀請展**
　Invitational Exhibition

簡　歷｜Profile

現為泰國佛光山泰華寺住持暨新馬泰印教區導師、曼
谷 IBPS 董事會董事長等重要職務。曾任佛光山第五、
六任住持。和尚溫和慈悲，梵唄唱誦攝受人心。

The Presiding Abbot of FGS Thaihua Temple Thailand, the
Instructor of the Diocese of Singapore, Malaysia, Thailand,
and India, and the Chairman of the Bangkok IBPS Board of
Directors. He has previously served as the fifth and sixth Abbot
of FGS. He is gentle and compassionate. His soothing chants of
Buddhist hymns are well-received by the disciples.

創作理念｜Concept

以師志為已志
以佛心為已心

To treat Master's aspirations as my own aspirations.
To treat Buddha's mind as my own mind.

宣紙　書法
Rice Paper - Calligraphy

36×68.5cm

以佛心為己心

以師志為己志

二〇二一年八月二十九日
心定敬書於佛光山泰華寺

但願眾生得離苦
不為自己求安樂

Wishing all Sentient Beings be Free from Suffering
Not Seeking My Own Comfort and Pleasure

心定和尚｜臺灣 ／ HSIN TING｜Taiwan

● 2021 邀請展
　　Invitational Exhibition

創作理念 ｜ Concept

但願眾生得離苦

不為自己求安樂

Wishing all Sentient Beings be Free from Suffering
Not Seeking My Own Comfort and Pleasure

宣紙　書法
Rice Paper - Calligraphy

36×68.5cm

但願眾生得離苦

不為自己求安樂

佛光山泰華寺心定　書

21

如意

Fulfilled Wishes

心保和尚 ｜ 臺灣 ／ HSIN BAU ｜ Taiwan

● 2020 邀請展
Invitational Exhibition

簡　歷 ｜ Profile

佛光山現任住持。曾於美國佛光山別分院道場弘法
二十餘年並任西來寺當家至住持。和尚領眾薰修，樂
說善法緣結十方。

Current Head Abbot of Fo Guang Shan Monastery. Former
Superintendent to Head Abbot at Hsilai Temple. Preached
Dharma at the US FGS branch temple for over 20 years, he has
guided devotees to practice cultivation and created affinities
with all.

創作理念 ｜ Concept

祝福大家心想事成。

May all wishes come true.

宣紙　書法
Rice Paper - Calligraphy

36×68.5cm

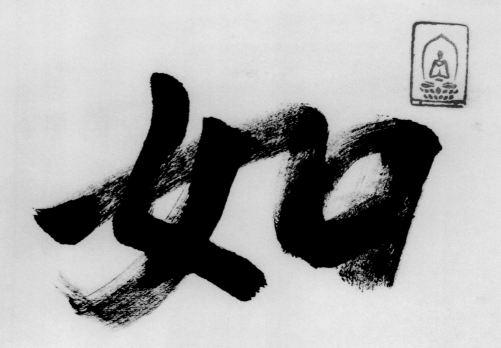

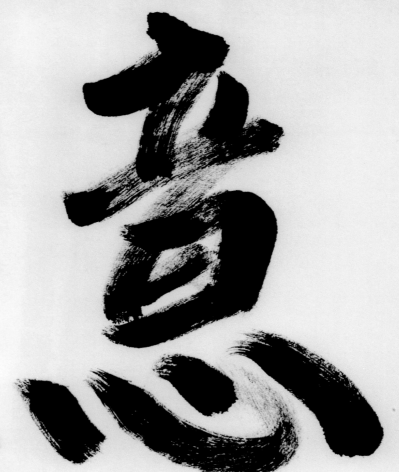

如意

心保

師徒情

Affections between Master and Disciples

慧延法師 | 臺灣 ╱ HUI YAN | Taiwan

● 2019 邀請展
Invitational Exhibition

簡　歷 | Profile

現任總本山都監院攝影組組長，在星雲大師的栽培
下，透過工作學習十五年的攝影，負責大師出席重要
活動、貴賓會見及總本山重要活動等拍照攝影，為佛
光山留下重要的影像紀錄。

Under the cultivation of Venerable Master Hsing Yun, he has
worked and studied photography for 15 years. He is in charge
of taking photos for Venerable Master at important events
and meetings with VIPs. His work has helped FGS document
important photographic images throughout the years.

創作理念 | Concept

大師常說與弟子關係是三分師徒、七分道友。大師對
弟子的關愛與互動，在鏡頭下顯得格外動人。

The Venerable Master often said that the relationship with
his disciples is three-parts of guidance and seven-parts of
friendship. The love and interaction between the Master and
his disciples is particularly moving under the lens.

有佛法就有辦法

Where Dharma is, There Lies the Way

慧是法師 | 馬來西亞 ╱ HUI SHI | Malaysia

● 2019 **邀請展**
Invitational Exhibition

簡　歷 | Profile

現任總本山寺務監院室普賢殿殿主。曾派駐大陸、臺
灣別分院道場，擅長知客接待及書法。出版《行者》
一書。

Current Director of the Great Practice Shrine. He has previously
served in FGS branches in Mainland China and Taiwan. He is
skilled in guest services and calligraphy. He has published the
book, *Practitioner*.

創作理念 | Concept

以大師文字，先大破，再重立，七字中，大小不拘，
「佛」字是亮點，整體見一氣呵成，躍昇成立體書法
創作。

As Venerable Master's writing, one should go back to the origin
then recreate. There is no limit among the seven characters.
The "Buddha" character is the highlighted focus. The entire
writing is consistent and elevated a three-dimentional
calligraphy creation.

宣紙　書法
Rice Paper - Calligraphy

90×120cm

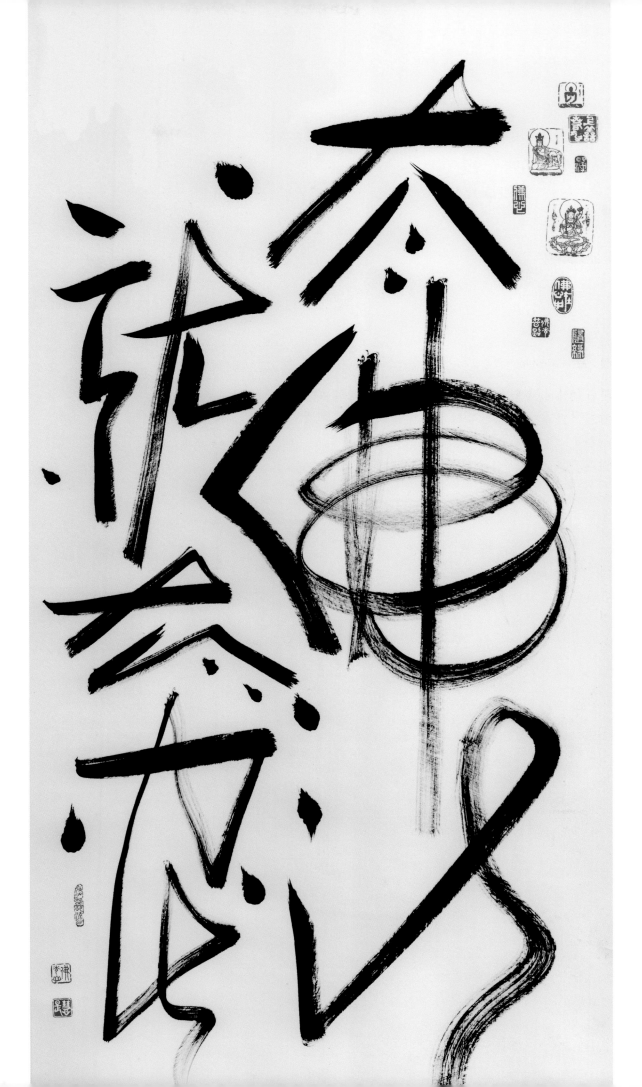

微笑觀音

Smiling Avalokitesvara

道璞法師 | 臺灣 ／ DAO PU | Taiwan

● 2020 邀請展
 Invitational Exhibition

簡　歷 | Profile

現任開山寮法堂書記二室書記，擅長繪畫。曾服務於佛光大藏經編藏處，早期受派駐日本弘法並學習漫畫創作。

Currently serving at the Residence of the Founding Master. Skillful at painting, she has previously served at the Buddhist Canon Research Department and was dispatched to Japan in the early period.

創作理念 | Concept

世間苦難多，祈願菩薩示現，讓眾生能發自內心的微笑，使世界充滿祥和溫暖，受苦眾生，身心自在、平安吉祥。

There are many sufferings in the world, and I pray that Bodhisattvas manifest. I wish that all sentient beings may smile from the their inner heart, and the world be filled with peace and warmth. Everyone who have suffered hardship will be carefree in body and mind, be safe and enjoy auspiciousness.

壓克力彩
Acrylic Color

79×200cm

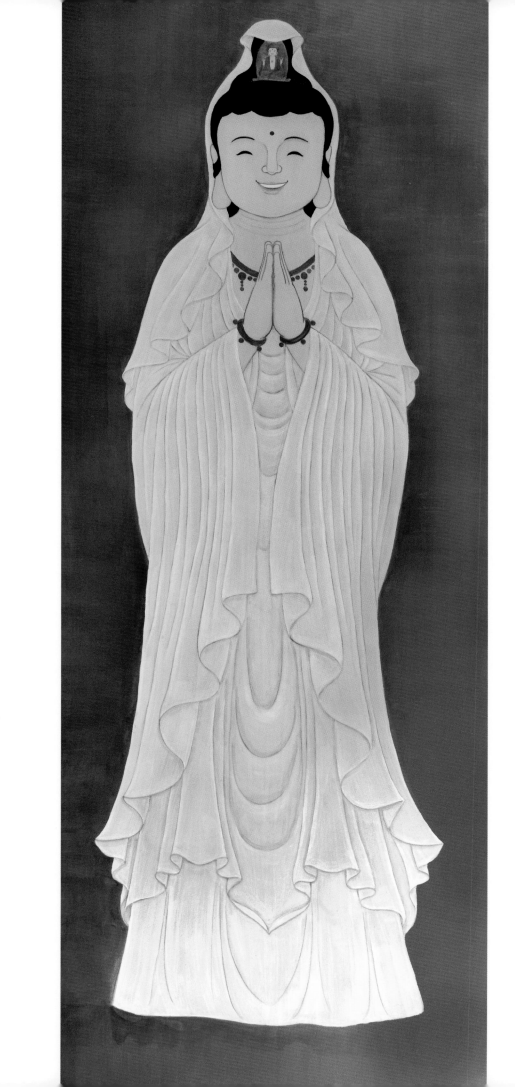

一線成佛

Become A Buddha with One Line

有紀法師｜新加坡 ／ YOU JI ｜ Singapore

● 2019 邀請展
Invitational Exhibition

簡　歷 | Profile

現於澳洲佛光山南天寺。曾服務於澳洲西澳道場、
《世界佛教美術圖說大辭典》英文版編輯組。擅長佛
教美術創作。

Currently serving at Nan Tien Temple in Australia. She has also
served at the IBAA Western Australia and the *Encyclopedia of
World Buddhist Arts*. She is skilled at Buddhism art creations.

創作理念 | Concept

以星雲大師「一筆字」概念為基礎，「一線成佛」以
一條線勾勒出佛像，加上塗鴉禪畫與色彩，展現心中
的佛。

Based on the concept of Venerable Master Hsing Yun's "One
Stroke Calligraphy," "Become A Buddha with One Line" uses
a single line to outline the Buddha, with added handwriting,
Chan paintings, and colors to reveal the Buddha from my inner
mind.

壓克力彩
Acrylic Color

29.7×42cm

父母恩重難報經
Filial Piety Sutra

覺源法師 ｜ 臺灣 ／ JUE YUAN ｜ Taiwan

● 2021 邀請展
Invitational Exhibition

多塗脂粉或薰蘭麝如是裝飾即得知
是女流之身而今死後白骨一般教弟
子等如何認得
佛告阿難若是男子在世之時入於伽
藍聽講經律禮拜三寶念佛名號所以
其骨色白且重世間女人短於智力易
溺於情生男育女認為天職每生一孩
賴乳養命乳由血變每孩飲母八斛四
斗甚多白乳所以憔悴骨現黑色其量
亦輕
阿難聞語痛割於心重淚悲泣白言世
尊母之恩德云何報答
佛告阿難汝今諦聽我當為汝分別解
說
母胎懷子凡經十月甚為辛苦在母胎
時第一月中如草上珠朝不保暮晨聚
將来午消散去母懷胎時第二月中恰
如凝酥母懷胎時第三月中猶如凝血
母懷胎時第四月中稍作人形母懷胎
時第五月中兒在母腹生有五胞何者
為五頭為一胞兩肘兩膝各為一胞共
成五胞母懷胎時第六月中兒在母腹
六精齊開何者為六眼為一精耳為二
精鼻為三精口為四精舌為五精意為
六精母懷胎時第七月中兒在母腹生
成骨節三百六十及生毛孔八萬四千

簡 歷 ｜ Profile

現任佛光山佛陀紀念館佛光樓主任。曾服務於總本山修持
監院室抄經堂及派駐日本弘法。

Current Deputy Executive at the Buddha Museum. She has served at
the Sutra Calligraphy Hall. She was previously dispatched to Japan.

宣紙　書法
Rice Paper - Calligraphy

77×28.5cm（7 張）

南無本師釋迦牟尼佛
南無本師釋迦牟尼佛
南無本師釋迦牟尼佛
開經偈
無上甚深微妙法
百千萬劫難遭遇
我今見聞得受持
願解如來真實義
佛說父母恩重難報經
姚秦三藏法師鳩摩羅什譯
如是我聞一時佛在舍衛國祇樹給孤
獨園與大比丘二千五百人菩薩摩訶
薩三萬八千人俱
爾時世尊引領大眾直往南行忽見路
邊聚骨一堆爾時如來向彼枯骨五體
投地恭敬禮拜
阿難合掌白言世尊如來是三界大師
四生慈父眾人歸敬以何因緣禮拜枯
骨
佛告阿難汝等雖是吾上首弟子出家
日久知事未廣此一堆枯骨或是我前
世祖先多生父母以是因緣我今禮拜
佛告阿難汝今將此一堆枯骨分作二
分若是男骨色白且重若是女骨色黑
且輕

創作理念 │ Concept

透過抄寫經文把心放慢、放柔軟，以心運腕。置心一處之
抄經修持方法。

Slow down and soften your mind by sutra calligraphy. Move your
wrists with your heart. The mind is focused on the practice method of
copying the sutras.

書法金石類

Calligraphy and Epigraphy

明・洪應明《菜根譚》

"The Roots of Wisdom" by Hong Ying-ming, Ming Dynasty

永威法師 | 臺灣 ╱ YUNG WEI | Taiwan

● 2018 書法金石類 佛光獎
 Calligraphy and Epigraphy Fo Guang Award

簡　歷 | Profile

現於澳洲佛光山南天寺。曾服務於佛光緣美術館澳洲墨爾
本館，長期於澳洲佛光山弘法等。

Currently serving at the Nan Tien Temple in Australia. She also previously served at the Fo Guang Yuan Art Gallery in Melbourne and has been promoting Buddhism in Australia for a long time.

創作理念 | Concept

當下一念，隨心所寫，心到手到，無拘無束，水墨交融，
來去自如。

The writing came at a moment of thought. Unfettered, the mind and hands at work. Water and ink permeate, coming and going at perfect ease.

宣紙　書法
Rice Paper - Calligraphy

90×120cm

氣為不敢雲庭なぎ

閒花芳洲主閒せ志

沖雪遠雲老雲鈴

心居玉子四月 七十天壽

大寶積經（一組 13 件）

Maharatnakuta Sutra (A Set of 13)

覺源法師｜臺灣 ／ JUE YUAN｜Taiwan

● 2019 書法金石類 佛光獎
　　Calligraphy and Epigraphy Fo Guang Award

菩薩四法世世不失菩提之心乃至道場自然現
前復次迦葉菩薩有四法所生善法滅不增長何
謂為四以憍慢心讀誦修學路伽耶經貪利養心
詣諸檀越增毀菩薩所未聞經違逆不信迦葉是
為菩薩四法所生善法減不增長復次迦葉菩薩
有四法所生善法增長不失何謂為四捨離邪法
求正經典六波羅蜜菩薩法藏心無憍慢於諸眾
生謙卑下下如法得施知量知足離諸邪命安住
聖種不出他人罪過虛實不求人短若於諸法心
不通達作如是念佛法無量隨眾所樂而為演說
唯佛所知非我所解以佛為證不生違逆迦葉是
為菩薩四法所生善法增長不失復次迦葉菩薩
有四曲心法所應遠離何謂為四曲心所應遠離
悔於諸眾生憍慢瞋恨於他利養起嫉妒心訶罵
菩薩廣其惡名迦葉是為菩薩四曲心之相何所犯眾
復次迦葉菩薩有四直心之相何謂為四所犯眾
罪終不覆藏向他發露心無蓋纏若失國界身命
財利如是急事終不妄語亦不餘言一切惡事罵
詈毀謗撾打繫縛種種傷害受是苦時但自咎責
自依業報不瞋恨他安住信力若聞甚深難信佛

簡　歷｜Profile

現任佛光山佛陀紀念館佛光樓主任。曾服務於總本山修持
監院室抄經堂及派駐日本弘法。

Current Deputy Executive at the Buddha Museum. She has served at
the Sutra Calligraphy Hall. She was previously dispatched to Japan.

大寶積經卷第一百一十二
普明菩薩會第四十三
如是我聞一時佛在王舍城耆闍崛山中與大比
丘眾八千人俱菩薩摩訶薩萬六千人皆是阿惟
越致從諸佛土而來集會悉皆一生當成無上正
真大道爾時世尊告大迦葉菩薩有四法退失智
慧何謂為四不尊重法不敬法師所受深法祕不
說盡有樂法者為作留難說諸因緣沮壞其心憍
慢自高卑下他人迦葉是為菩薩四法退失智慧
復次迦葉菩薩有四法得大智慧何謂為四常尊
重法恭敬法師隨所聞法以清淨心廣為人說不
求一切名聞利養知從多聞生於智慧勤求不懈
如救頭然聞經誦持樂如說行不隨言說迦葉是
為菩薩四法得大智慧復次迦葉菩薩有四法失
菩提心何謂為四欺誑師長已受經法而不恭敬
無疑悔處令他疑悔求大乘者訶罵誹謗廣其惡
名以諂曲心與人從事迦葉是為菩薩四法失菩
提心復次迦葉菩薩有四法世世不失菩提之心
乃至道場自然現前何謂為四失命因緣不以妄
語何況戲笑常以直心與人從事離諸諂曲於諸

（局部）

創作理念 ｜ Concept

透過抄寫經文把心放慢、放柔軟，以心運腕。置心一處之
抄經修持方法。

Slow down and soften your mind by sutra calligraphy. Move your
wrists with your heart. The mind is focused on the practice method of
copying the sutras.

宣紙　書法
Rice Paper - Calligraphy

890.5×27cm

我是佛

I am Buddha

如駿法師 | 臺灣 ╱ RU JUN | Taiwan

● 2020 書法金石類 佛光獎
 Calligraphy and Epigraphy Fo Guang Award

簡　歷 | Profile

現於佛光山寶華寺。曾服務於泰山禪淨中心、福山寺、首
爾佛光山寺等。

Currently serving at Bao Hua Temple. She has also served at Taishan
Meditation Center, Fu Shan Temple, and Seoul Fo Guang Shan
Temple.

創作理念 | Concept

星雲大師說「我是佛」。
五祖常勸僧俗：「但持《金剛經》，即自見性，直了成佛。」

Venerable Master Hsing Yun said, "I am a Buddha". The fifth patriarch
often advised monks and laymen, "If you uphold the *Diamond Sutra*,
you will be able to see your true nature and attain Buddhahood."

宣紙　書法
Rice Paper - Calligraphy

63x120cm

二〇二〇三一〇佛弟子 如駿 恭書

恆河沙、戒定真香、我是佛、空有一如、海納百川、花開見佛

The Sand of the River Ganges
The True Fragrance of Precept and Samadhi
 I am Buddha
Sameness of Empty and Existent
The Ocean Accepts All Waters
Seeing the Buddha When the Flower Blooms

妙暘法師 | 臺灣 ／ MIAO YANG | Taiwan

● 2021 書法金石類 佛光獎
 Calligraphy and Epigraphy Fo Guang Award

簡　歷 | Profile

現任佛光大學會計室會計主任。曾任總本山司庫室主任、
南華管理學院會計等。

Currently serving as Accountant at Fo Guang University. She has also
served at the Financial Management Office and the College of
Management in Nanhua University.

創作理念 | Concept

以佛教名相及師父上人法語為篆刻題材，希望將佛教精神
及中國文字之美結合，呈現佛教藝術寧靜之美。

The theme is the Buddhist terminology and Master's Dharma word.
Hope to combine the Buddhist's spirit with the beauty of Chinese
characters to present the tranquil beauty of Buddhist art.

玉石
Jade

2.1×2.1×6.8~2.4×2.4×6.8cm

不忘初心

Never Forget One's Initial Aspirations

永威法師 | 臺灣 ╱ YUNG WEI | Taiwan

● 2017 陶藝、工藝、書法類 菩提獎
 Ceramics, Artifacts and Calligraphy Bodhi Award

簡　歷 | Profile

現於澳洲佛光山南天寺。曾服務於佛光緣美術館澳洲墨爾本館，長期於澳洲弘法等。

Currently serving at the Nan Tien Temple in Australia. She also previously served at the Fo Guang Yuan Art Gallery in Melbourne and has been promoting Buddhism in Australia for a long time.

創作理念 | Concept

當下一念隨心所寫，心到手到無拘無束；水、墨交融，來去自如。

The writing came at a moment of thought. Unfettered, the mind and hands at work. Water and ink permeate, coming and going at perfect ease.

宣紙　書法
Rice Paper - Calligraphy

25.5x25.5cm

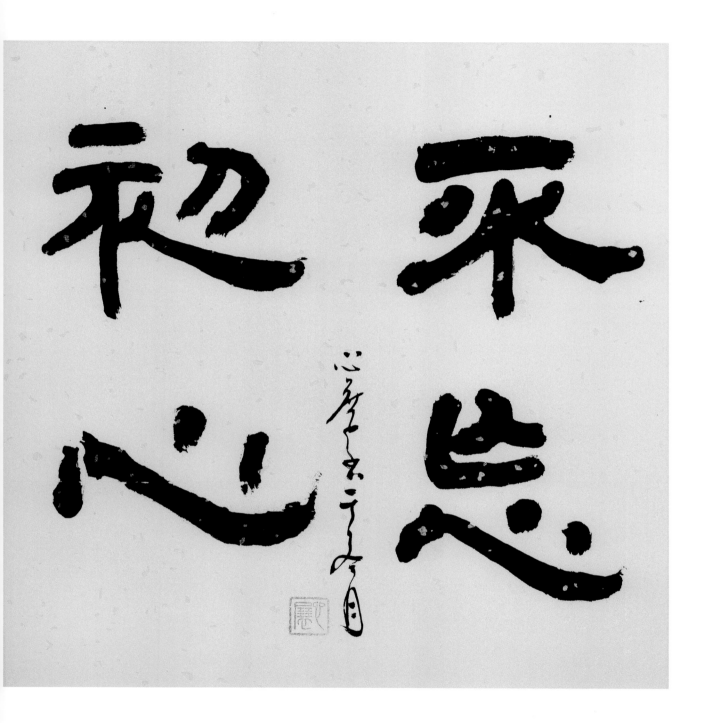

45

古今一夢

A Dream of Now and Then

永威法師｜臺灣 ／ YUNG WEI｜Taiwan

● 2017 陶藝、工藝、書法類 菩提獎
　　Ceramics, Artifacts and Calligraphy Bodhi Award

創作理念 ｜ Concept

當下一念隨心所寫，心到手到無拘無束；水、墨交融，來
去自如。

The writing came at a moment of thought. Unfettered, the mind and hands at work. Water and ink permeate, coming and going at perfect ease.

宣紙　書法
Rice Paper - Calligraphy

42x35cm

古今一夢浮生
短厚德如量
豈容緩勸
勞易迷真惱
怠晨昏奪
伴佛法僧

心廬書

心經（四條屏）

Heart Sutra (Four Screens)

堅寬法師｜臺灣 ／ CHIEN KUAN｜Taiwan

● 2018 書法金石類 菩提獎
　　Calligraphy and Epigraphy Bodhi Award

簡　歷｜Profile

現任中國大陸鑑真圖書館禪講師。曾任總本山修持監院室
淨業林堂主，曾於澳洲、紐西蘭弘法多年，擔任弘講師等
職。

Current Lay Dharma Teacher of Jianzhen Library. She has served
at Amitabha Chanting Hall. She has also preached the Dharma in
Australia and New Zealand for many years.

創作理念｜Concept

在文化之城的揚州，以禪心練字。心儀曹全碑的優雅，蠶
頭雁尾，曼妙弧線若舞。

I have practiced the Chinese calligraphy with Chan mind and admired
the elegance of Stele of Cao Quan in Yangzhou. The curved line is like
that of a silkworm head and wild goose tail, dancing gracefully.

宣紙　書法
Rice Paper - Calligraphy

32x134cm

觀自在菩薩行深般若波羅蜜多時照見五蘊皆
空度一切苦厄舍利子色不異空不異色色
即是空空即是色受想行識亦復如是舍利子
是諸法空相不生不滅不垢不淨不增不減是

故空中無色無受想行識無眼耳鼻舌身意無
色聲香味觸法無眼界乃至無意識界無無明
亦無無明盡乃至無老死亦無老死盡無苦集
滅道無智亦無所得以無所得故菩提薩埵依般

（局部）

49

六度

Six Perfections

滿寂法師 | 臺灣 ／ MAN JI | Taiwan

● 2019 書法金石類 菩提獎
 Calligraphy and Epigraphy Bodhi Award

簡　歷 | Profile

現於總本山典座監院室雲居樓餐飲組。曾於佛光山寶塔寺
等臺灣別分院道場弘法。

Currently serving as the Temple Chef at the Cloud Dwelling Building.
Previously preached Dharma at Bao Ta Temple, etc.

創作理念 | Concept

以歡喜心結緣。感謝師父上人與常住讓徒眾有因緣參展。

Developing good affinities with a joyful mind. Thanks to the Master
and monastery for giving disciples the opportunity to participate in
this exhibition.

玉石
Jade

篆刻 3×2×5cm
宣紙 47×50cm

南無觀世音菩薩、空假中三觀、波羅蜜、福滿人間、年年有餘

Homage to Avalokitesvara Bodhisattva
Threefold Contemplation of Emptiness, Deception and Middle Way
Paramita
A World Filled with Good Fortune
Have Abundance Year after Year

妙暘法師｜臺灣 ／ MIAO YANG｜Taiwan

● 2020 書法金石類 菩提獎
　　Calligraphy and Epigraphy Bodhi Award

簡　歷｜Profile

現任佛光大學會計室會計主任。曾任總本山司庫室主任、
南華管理學院會計等。

Currently serving as Accountant at Fo Guang University. She has
also served at the Financial Management Office and the College of
Management in Nanhua University.

創作理念｜Concept

以一刀一劃來加深對佛法的信念。以佛教名相、師父上人
法語，展現在篆刻作品。

Deepening one's belief in Buddhism with one cut and one stroke.
Displayed in the seal engravings are Buddhist terms and Master's
Dharma words.

玉石
Jade

2.4x2.4x7cm

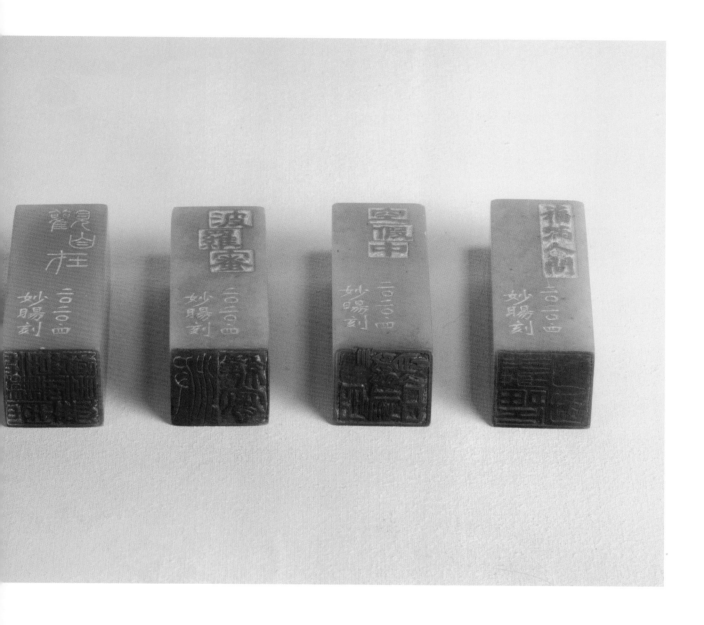

心經篆書

Heart Sutra in Seal Character

如得法師 | 臺灣 ／ RU DE | Taiwan

● 2021 書法金石類 菩提獎
 Calligraphy and Epigraphy Bodhi Award

簡　歷 | Profile

現任佛光山福國寺，曾服務於佛光精舍、金光明寺、月光寺、佛陀紀念館等。

Currently serving at Fu Guo Temple. She has also served at Fo Guang Senior Citizens Home, Jing Guang Ming Temple, Yue Guang Temple and Buddha Museum.

創作理念 | Concept

《心經》，基於對「中山銘文體」的喜歡。其因字體線條粗、細、輕、重的變化讓字體產生一種韻律之美，故以中山銘文體做為創作理念。

Appreciation for the *Heart Sutra* stemmed from the" Inscription Script." The changes in the thickness, thinness, lightness and weight of the font lines created a rhythmic beauty and became the inspiration of this work.

宣紙　書法
Rice Paper - Calligraphy

53×34.8cm

觀自在菩薩，行深般若波羅蜜多時，照見五蘊皆空，度一切苦厄。舍利子，色不異空，空不異色，色即是空，空即是色，受想行識，亦復如是。舍利子，是諸法空相，不生不滅，不垢不淨，不增不減。是故空中無色，無受想行識，無眼耳鼻舌身意，無色聲香味觸法，無眼界，乃至無意識界，無無明，亦無無明盡，乃至無老死，亦無老死盡，無苦集滅道，無智亦無得。以無所得故，菩提薩埵，依般若波羅蜜多故，心無罣礙，無罣礙故，無有恐怖，遠離顛倒夢想，究竟涅槃。三世諸佛，依般若波羅蜜多

心經

金剛經

Diamond Sutra

慧是法師｜馬來西亞 ／ HUI SHI｜Malaysia

● 2017 陶藝、工藝、書法類 般若獎
　　Ceramics, Artifacts and Calligraphy Prajna Award

簡　歷｜Profile

現任總本山寺務監院室普賢殿殿主。曾派駐大陸、臺灣別
分院道場，擅長知客接待及書法。出版《行者》一書。

Current Director of the Great Practice Shrine. He has previously served
at FGS branches in Mainland China and Taiwan. He is skilled in guest
services and calligraphy. He has published the book, *Practitioner*.

創作理念 | Concept

受師父上人一筆字影響而寫。四年時間近四千張與人結緣。
另類字畫自成一體。

Written with inspiration from the Master's one-stroke calligraphy,
nearly 4,000 pieces within four years have been written to develop
affinities with many people. The calligraphy and painting have a style
of its own.

宣紙　書法
Rice Paper - Calligraphy

135x34cm

佛光菜根譚（一）- 忙、佛光菜根譚（二）- 心
佛光菜根譚（三）- 敢、佛光菜根譚（四）- 禪

Humble Table, Wise Fare "1" - Busy
Humble Table, Wise Fare "2" - Mind
Humble Table, Wise Fare "3" - Bravery
Humble Table, Wise Fare "4" - Chan

滿吉法師 | 臺灣 ／ MAN JEE | Taiwan

● 2018 書法金石類 般若獎
Calligraphy and Epigraphy Prajna Award

簡　歷 | Profile

現任宗務堂檔案室主任。曾服務於佛光淨土文教基金會及
臺灣別分院道場等。

Currently serving as Board Director at the Office of Religious Affairs.
She previously served at the Pure Land Cultural & Educational
Foundation as well as other branch temples in Taiwan.

創作理念 | Concept

大師《佛光菜根譚》，猶如佛經中的四句偈，充滿佛法。
佐以插畫，自我提醒，也與大眾共勉。

The *Humble Table, Wise Fare* just like four verses in the sutras, is full of
Dharma. With illustrations, it serves as a reminder to ourselves and to
be shared with everyone.

宣紙　書法
Rice Paper - Calligraphy

30x115cm

（局部）

心經

Heart Sutra

邱淑芬師姑｜馬來西亞 ／ QIU SHU FEN｜Malaysia

- 2019 書法金石類 般若獎
 Calligraphy and Epigraphy Prajna Award

簡　歷｜Profile

現於馬來西亞佛光山南方寺。曾服務於馬來西亞佛光山新馬寺、上海星雲文教館美術館等。

Currently serving at the Nan Fang Buddhist Missionary, Malaysia. She has served at Hsing Ma Shi and the Art Gallery of Hsing Yun Culture and Education Center in Shanghai.

般若波羅蜜多心經

觀自在菩薩行深般若波羅蜜多時照見五蘊皆空度一切苦厄舍利子色不異空空不異色色即是空空即是色受想行識亦復如是舍利子是諸法空相不生不滅不垢不淨不增不減是故空中無色無受想行識無眼耳鼻舌身意無色聲香味觸法無眼界乃至無意識界

創作理念 | Concept

以抄經為功課，以此供養，願觀者歡喜。

Practicing sutra calligraphy as an assignment, and making it an offering to all. Wish it brings joy to all viewers.

宣紙　書法
Rice Paper - Calligraphy

138×34cm

四大皆空示現有　五蘊和合亦非真

The Four Elements Truly Exist
The Five Aggregates were Never True

童純純師姑｜臺灣　／　TUNG TSUN TSUN｜Taiwan

● 2020 書法金石類 般若獎
　　Calligraphy and Epigraphy Prajna Award

簡　歷｜Profile

現於佛光山百萬人興學委員會。曾於傳燈樓客堂、總本山
寺務監院室電信組、佛光山文化發行部等單位服務。

Currently serving at FGS Million-Member Fundraising Committee. She
has also served at Dharma Transmission Building, Monastery Affairs
Department, and FGS Culture Promotion and Distribution Department.

創作理念｜Concept

師父上人的對聯，書之、習之。

Writing and learning Master's couplets.

宣紙　書法
Rice Paper - Calligraphy

45.5x202cm

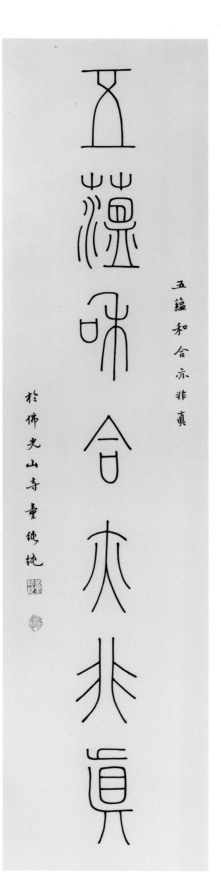

四大皆空示現有

五蘊和合亦非真

己亥清和月

於佛光山寺童純純

一心頂禮八十八佛

Wholeheartedly Prostrating to Eighty-eight Buddhas

永海法師 | 臺灣 ／ YUNG HAI | Taiwan

● 2021 書法金石類 般若獎
 Calligraphy and Epigraphy Prajna Award

簡　歷 | Profile

現任佛光精舍，曾服務於佛光山福國寺、普門雜誌社、覺世月刊及派駐馬來西亞東禪寺弘法。

Current serving at Fo Guang Senior Citizens Home. She has previously served at Fu Guo Temple, *Pu-Men Magazine* and *Awakening the World Periodical*. She has also preached in Malaysia.

創作理念 | Concept

以篆書體抄寫八十八佛，除了可以幫助修行人安住身心，還可以開發禪定與智慧；此外，以全開宣紙書寫，方便行者吊掛起來讀誦和禮拜，是一種非常適當的修行方法與工具。

Copying the Eighty-eight Buddhas in seal script can help practitioners settle the body and mind in peace, as well as develop meditation and wisdom. Writing on fully open rice paper allows one to hang the written script to chant and prostrait it. It is an appropriate way and tool to practice the Dharma.

宣紙　書法
Rice Paper - Calligraphy

138×70cm

一心頂禮八十八佛

大慈大悲愍眾生
大喜大捨濟含識
相好光明以自嚴
眾等至心歸命禮

南無皈依十方盡虛空界一切諸佛
南無皈依十方盡虛空界一切尊法
南無皈依十方盡虛空界一切賢聖僧

南無如來應供正遍知明行足善逝世間解
無上士調御丈夫天人師佛世尊

南無普光佛
南無普明佛
南無普淨佛
南無多摩羅跋栴檀香佛
南無栴檀光佛
南無摩尼幢佛
南無歡喜藏摩尼寶積佛
南無一切世間樂見上大精進佛
南無摩尼幢燈光佛
南無慧炬照佛
南無海德光明佛
南無金剛牢強普散金光佛
南無大強精進勇猛佛
南無大悲光佛
南無慈力王佛
南無慈藏佛
南無栴檀窟莊嚴勝佛
南無賢善首佛
南無善意佛
南無廣莊嚴王佛
南無金華光佛
南無寶蓋照空自在力王佛
南無虛空寶華光佛
南無琉璃莊嚴王佛
南無普現色身光佛
南無不動智光佛
南無降伏眾魔王佛
南無才光明佛
南無智慧勝佛
南無彌勒仙光佛
南無善寂月音妙尊智王佛
南無世淨光佛
南無龍種上尊王佛
南無日月光佛
南無日月珠光佛
南無慧幢勝王佛
南無師子吼自在力王佛
南無妙音勝佛
南無常光幢佛
南無觀世燈佛
南無慧威燈王佛
南無法勝王佛
南無須彌光佛
南無須曼那華光佛
南無優曇鉢羅華殊勝王佛
南無大慧力王佛
南無阿閦毘歡喜光佛
南無無量音聲王佛
南無才光佛
南無金海光佛
南無山海慧自在通王佛
南無大通光佛
南無一切法常滿王佛
南無釋迦牟尼佛
南無金剛不壞佛
南無寶光佛
南無龍尊王佛
南無精進軍佛
南無精進喜佛
南無寶火佛
南無寶月光佛
南無現無愚佛
南無寶月佛
南無無垢佛
南無離垢佛
南無勇施佛
南無清淨佛
南無清淨施佛
南無娑留那佛
南無水天佛
南無堅德佛
南無栴檀功德佛
南無無量掬光佛
南無光德佛
南無無憂德佛
南無那羅延佛
南無功德華佛
南無蓮華光遊戲神通佛
南無財功德佛
南無德念佛
南無善名稱功德佛
南無紅燄帝幢王佛
南無善遊步功德佛
南無鬥戰勝佛
南無善遊步佛
南無周匝莊嚴功德佛
南無寶華遊步佛
南無寶蓮華善住娑羅樹王佛
南無法界藏身阿彌陀佛

佛曆二五六四年歲次辛丑春分　釋永海于佛光山寺

子德芬芳

Prosperous Future Generations

覺源法師 | 臺灣 ／ JUE YUAN | Taiwan

簡　歷 | Profile

現任佛光山佛陀紀念館佛光樓主任。曾服務於
總本山修持監院室抄經堂及派駐日本弘法。

Current Deputy Executive at the Buddha Museum.
She has served at the Sutra Calligraphy Hall. She was
previously dispatched to Japan.

創作理念 | Concept

星雲大師 2008 鼠年的新春法語。藉此祝福大家
一切吉祥，平安順利。

Venerable Master Hsing Yun's Chinese New Year
message for the Year of the Mouse in 2008. Wish all of
you auspiciousness, peacefulness and wellness.

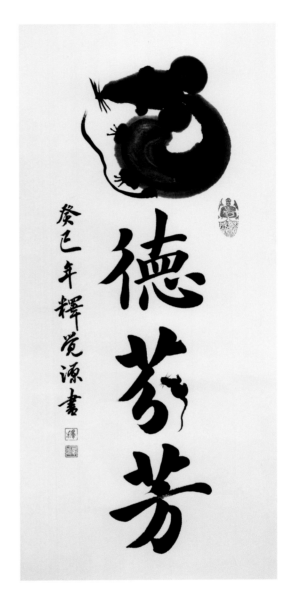

宣紙　書法
Rice Paper - Calligraphy

890.5×27cm

六念

Six Contemplations

滿寂法師 | 臺灣 ╱ MAN JI | Taiwan

● 2020 書法金石類 優選獎
 Calligraphy and Epigraphy Merit Award

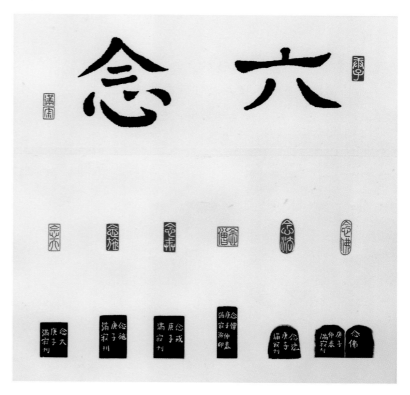

簡　歷 | Profile

現為總本山典座監院室雲居樓餐飲組。曾於佛光山寶塔寺等臺灣別分院道場弘法。

Currently serving as the Temple Chef at the Cloud Dwelling Building. Previously preached Dharma at Bao Ta Temple, etc.

創作理念 | Concept

以歡喜心結緣。感謝師父上人與常住讓徒眾有因緣參展。

Developing good affinities with a joyful mind. Thanks to the Master and monastery for giving disciples the opportunity to participate in this exhibition.

玉石
Jade

2.4x2.4x6.5cm ~ 4.2x1.7x4.4cm

心經

Heart Sutra

堅寬法師｜臺灣 ╱ CHIEN KUAN｜Taiwan

● 2020 書法金石類 優選獎
Calligraphy and Epigraphy Merit Award

簡　歷｜Profile

現任中國大陸鑑真圖書館禪講師。曾任總本山修持監院室淨業林堂主，曾於澳洲、紐西蘭弘法多年，擔任弘講師等職。

Current Lay Dharma Teacher of Jianzhen Library. She has served at Amitabha Chanting Hall. She has also preached the Dharma in Australia and New Zealand for many years.

創作理念｜Concept

疫情期間，以練字為自課、結緣，法喜充實。無常時節，安住就能自在。

During the epidemic, I practiced calligraphy as homework to develop good affinities and was fulfilled with Dharma joy. My mind is calm and at perfect ease despite the impermanence around me.

宣紙　書法
Rice Paper - Calligraphy

34.5x138cm

人間佛教回歸佛陀本懷

Humanistic Buddhism's Return to the Original Intents of the Buddha

妙霖法師 | 臺灣 ╱ MIAO LIN | Taiwan

● 2019 書法金石類 優選獎
Calligraphy and Epigraphy Merit Award

簡　歷 | Profile

現任中國大陸南京天隆寺寺務主任。曾任南京雨花精舍監寺、佛光祖庭大覺寺女眾部監學、永和學舍住持等。

Currently serving as Chief Executive at Tianlong Temple in Nanjing. She has previously served at the Yuhua Vihara, Yixing Dajua Temple and Younghe Temple.

創作理念 | Concept

響應師父上人《人間佛教回歸佛陀本懷》特書寫之。

This calligraphy is especially written as a response to Master's "Humanistic Buddhism: Holding True to the Original Intents of Buddha."

宣紙　書法
Rice Paper - Calligraphy

35×180cm

心經
Heart Sutra

妙敬法師｜臺灣／MIAO CHING｜Taiwan

● 2020 書法金石類 優選獎
 Calligraphy and Epigraphy Merit Award

簡　歷｜Profile

現於總本山修持監院室淨業林。曾服務於佛光山潮州講堂等臺灣別分院道場。

Currently serving at Amitabha Chanting Hall. She has previously served at the Chaojhou Lecture Hall and FGS branch temples in Taiwan.

創作理念｜Concept

欣賞趙孟頫書法，故以臨摹作品提升書藝。

Inspired by Zhao Meng Fu's calligraphy, by imitating his works, improved my calligraphy writing.

宣紙　書法
Rice Paper - Calligraphy

35x136cm

心經

Heart Sutra

如宣法師｜臺灣 ╱ RU SHUAN｜Taiwan

● 2019 書法金石類 優選獎
 Calligraphy and Epigraphy Merit Award

簡　歷｜Profile

現任佛光大藏經編藏處，曾服務於總本山修持
監院室淨業林、文化院、人間福報等。

Currently serving at the Buddhist Canon Research
Department, Amitabha Chanting Hall, Culture Council
and *The Merit Times*.

創作理念｜Concept

以戰國中山王國篆體字，抄寫《心經》一部，
呈現「般若皆空」之精神。

Copied the *Heart Sutra* to present the spirit of "All
Prajna is Emptiness." Presented in the seal character of
the Chuzan Kingdom from the Warring States period.

宣紙　書法
Rice Paper - Calligraphy

35×139cm

做自己貴人

Be Your Own Mentor

妙主法師 | 臺灣 ／ MIAO ZHU | Taiwan

● 2019 書法金石類 優選獎
　Calligraphy and Epigraphy Merit Award

簡　歷 | Profile

現於佛光山佛光大藏經編藏處。曾服務於佛
光出版社、佛光山南台別院、總本山典座監
院室雲居樓、大林講堂等。

Currently serving at the Buddhist Canon Research
Department. She has also served at the Fo Guang
Publishing House, Nan Tai Temple, Cloud Dwelling
Building, and Dailin Lecture Hall.

創作理念 | Concept

大師所說：凡事求助於人很難，唯有直下承
擔，自己有辦法了，任誰也打倒不了你。

The Master said, "It's difficult to ask for help in
everything. The only solution is to immediately
accept the responsibilities. Once you figured out a
way on your own, no one can defeat you."

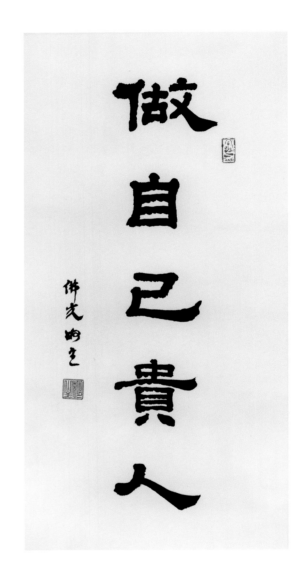

宣紙　書法
Rice Paper - Calligraphy

34×70cm

禪心

Chan Mind

妙豪法師 | 馬來西亞 ／ MIAO HAO | Malaysia

● 2019 書法金石類 優選獎
Calligraphy and Epigraphy Merit Award

簡 歷 | Profile

現任馬來西亞佛光山東禪佛教學院。曾服務
於馬來西亞佛光文教中心監寺。

Currently serving as Dong Zen Institute of Buddhist
Studies. She has previously served at the
Superintendent of Persatuan Meditasi FGS Selangor,
Dong Zen Temple Malaysia, etc.

創作理念 | Concept

禪心能啟發人的內在，觀事、觀人、觀物、
觀境都自在。

Chan mind can enlighten the inner conscious of
humans, and help to attain perfect ease through
contemplating things, people, objects, and realms.

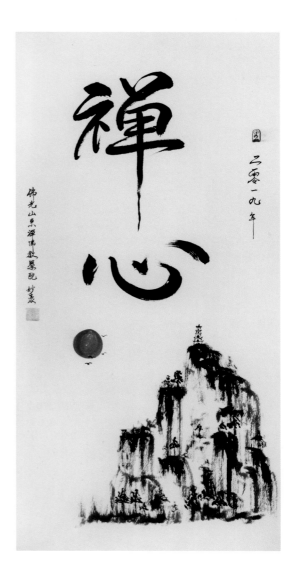

宣紙　書法
Rice Paper - Calligraphy

40×73cm

松濤流綠野　竹影掃紅塵

Pine Waves Flow through the Green Fields
Bamboo Shadows Cast over Humanity

知見法師｜臺灣 ／ ZHI JIAN｜Taiwan

● 2019 書法金石類 優選獎
　Calligraphy and Epigraphy Merit Award

簡　歷｜Profile

現於總本山信眾監院室客堂組。曾服務於佛光
山板橋講堂、佛陀紀念館五和塔喜慶之家主任、
文教廣場店長等。

Currently serving at Public Services Department. She
has previously served at Banqiao Lecture Hall, Five
Harmonies Pagoda and the Education Plaza.

創作理念｜Concept

星雲大師墨寶感動千萬人。弟子藉書法練心修
行。

Venerable Master Hsing Yun's calligraphy have
touched thousands of people. Through the practice of
calligraphy, I have trained my mind for cultivation.

宣紙　書法
Rice Paper - Calligraphy

34.5×105cm

星雲大師法語

Dharma Words of Venerable Master Hsing Yun

有林法師 | 臺灣 ／ YOU LIN | Taiwan

● 2020 書法金石類 優選獎
　Calligraphy and Epigraphy Merit Award

簡　歷 | Profile

現於佛光山屏東講堂。曾派駐北海道場、岡山
講堂、圓福寺、金光明寺等道場弘法。

Currently serving at Pingtung Lecture Hall. She has
previously served at Beihai Vihara, Gangshan Lecture
Hall, Yuan Fu Temple, Jing Guang Ming Temple, etc.

創作理念 | Concept

師父上人對空的闡釋淺顯易懂。弟子受益，故
書寫之。

Master's interpretation of Emptiness is clear and easy
to understand. I have received the benefits, therefore I
wrote it.

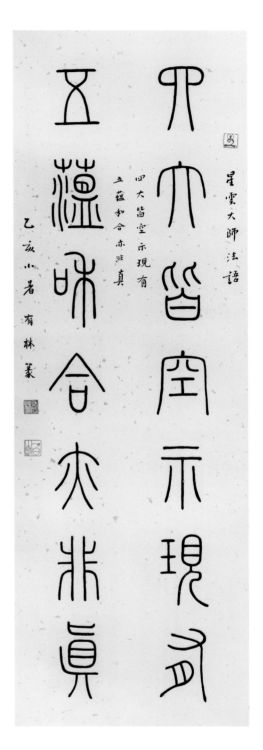

宣紙　書法
Rice Paper - Calligraphy

46x195cm

贈予星公上人〈金剛經無量壽塔〉

Diamond Sutra Amitayus Pagoda - Presented to Venerable Master Hsing Yun

妙逸法師｜臺灣／ MIAO YI｜Taiwan

● 2020 書法金石類 優選獎
Calligraphy and Epigraphy Merit Award

簡　歷｜Profile

現於總本山寺務監院室園藝二組。曾服務於佛光山台南講堂、總本山典座監院室雲居樓與國際佛光會中華總會等。

Currently serving at the Monastery Affairs Department. She has previously served at the Tainan Lecture Hall, the Cloud Dwelling Building, the Monastery Affairs Department, and BLIA, etc.

創作理念｜Concept

發願書寫金剛經塔為師父上人祝壽。

Making a vow to hand-scribe the *Diamond Sutra* Amitayus Pagoda to celebrate the Master's birthday.

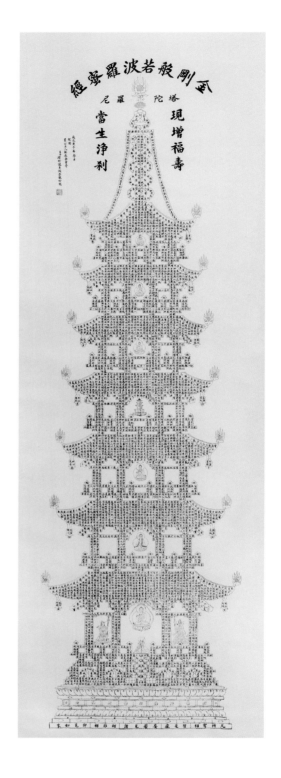

宣紙　書法
Rice Paper - Calligraphy

65×190cm

不與物拘透脫自在

The Mind Unwavered with Circumstances, Become Liberated and at Ease

童純純師姑｜臺灣／TUNG TSUN TSUN｜Taiwan

● 2019 書法金石類 優選獎
Calligraphy and Epigraphy Merit Award

簡　歷｜Profile

現於佛光山百萬人興學委員會。曾於總本山傳燈樓客堂、寺務監院室電信組、佛光山文化發行部等單位服務。

Currently serving at FGS Million-Member Fundraising Committee. She has also served at Dharma Transmission Building, Monastery Affairs Department, and FGS Culture Promotion and Distribution Department.

創作理念｜Concept

「不與物拘，透脫自在」，以書法篆書來呈現。

"Don't be tied to living beings, be liberated and be at ease," presented in seal character calligraphy.

宣紙　書法
Rice Paper - Calligraphy

30.5×131cm

佛光菜根譚

Humble Table, Wise Fare

永融法師｜臺灣 ／ YUNG JUNG｜Taiwan

● 2021 書法金石類 優選獎
　Calligraphy and Epigraphy Merit Award

簡　歷｜Profile

現任於佛光山佛陀紀念館副館長。曾服務於台
南講堂住持、普門寺住持、日光寺住持、台北
道場住持、傳燈會執行長等。

Current Deputy Curator of Buddha Museum. She has
also served at Light Transmission Council. She was the
Abbess of Tainan Lecture Hall, Pu Men Vihara, Ri Guang
Temple, and Taipei Vihara. She ws also the CEO of the
Light Transmission Council.

創作理念｜Concept

以師父上人佛光菜根譚作為創作題材。

Taking Venerable Master's book, "Humble Table Wise
Fare," as the creative theme.

宣紙　書法
Rice Paper - Calligraphy

35×136cm

般若心經

Heart Sutra

如宣法師 | 臺灣 ╱ RU SHUAN | Taiwan

● 2021 書法金石類 優選獎
 Calligraphy and Epigraphy Merit Award

簡 歷 | Profile

現任佛光大藏經編藏處，曾服務於總本山修持
監院室淨業林、文化院、人間福報等。

Currently serving at the Buddhist Canon Research
Department, Amitabha Chanting Hall, Culture Council
and *The Merit Times*.

創作理念 | Concept

貴有古意。運用薄如蟬翼的古黃仿舊雁皮宣紙，
以鐵線篆書寫《心經》，希冀傳遞先人手抄經
的古意。

The creative concept is that of "preciously ancient."
The *Heart Sutra* is written with iron thread seal on the
imitation of a very thin ancient rice paper. Hope to
convey the meaning of the ancestors' hand-written
scriptures.

宣紙　書法
Rice Paper - Calligraphy

35×139cm

23 號沙彌—毛毛蟲
Sramanera No. 23 - Caterpillar

覺具法師｜臺灣 ／ JUE JI｜Taiwan

● 2021 書法金石類 優選獎
 Calligraphy and Epigraphy Merit Award

簡 歷 | Profile

現為開山寮監寺。曾服務於佛光山蘭陽別院。擅長典座料理與教學，並出版有《和星雲大師一起吃飯》一書。

Current Superintendent of Residence of the Founding Master. Skilled at cooking and teaching, she previously served at Lanyang Temple. She has also published a book titled, *Having a Meal with Venerable Master Hsing Yun*.

創作理念 | Concept

喜歡用簡單的線條來表達作品，此次結合篆書＋纏繞畫，以毛筆的方式完成，自己覺得是自我的一種突破。

I like to use simple lines to express my works. It is a self-breakthrough by combining seal script with Zentangle to complete the work with a brush.

宣紙　書法
Rice Paper - Calligraphy

49×100cm

佛光菜根譚佳句選
"Humble Table, Wise Fare" Quotes:

滿寂法師 | 臺灣 ／ MAN JI | Taiwan

● 2021 書法金石類 優選獎
 Calligraphy and Epigraphy Merit Award

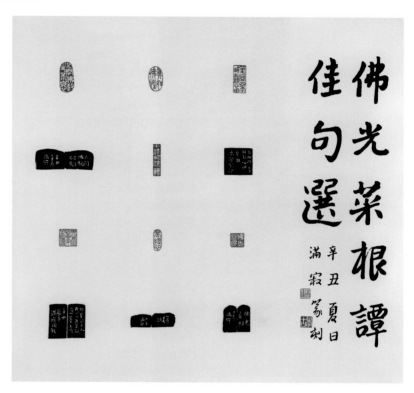

簡　歷 | Profile

現為總本山典座監院室雲居樓餐飲組。曾於佛光山寶塔寺等臺灣別分院道場弘法。

Currently serving as the Temple Chef at the Cloud Dwelling Building. Previously preached Dharma at Bao Ta Temple, etc.

創作理念 | Concept

以專心好學之心，呈現篆刻完美的線條，希望以歡喜心將藝術之美淨化心靈。

Presenting the perfect lines of seal carving with a dedicated and studious heart. Hopes to purify the soul with the beauty of art.

玉石
Jade

2.4×2.4×4.3cm ~ 5.6×1.2×4.9cm

般若心經
Heart Sutra

如啟法師 ｜ 臺灣 ╱ RU CHI ｜ Taiwan

● 2021 書法金石類 優選獎
　　Calligraphy and Epigraphy Merit Award

簡　歷 ｜ Profile

現任於佛光山北海道場。曾服務於草屯禪淨中心監寺、旗山禪淨中心、岡山禪淨中心等分別院道場。

Currently serving at Beihai Vihara. She has also served at Caotun and Cishan Meditation Center, Gangshan Lecture Hall, etc.

創作理念 ｜ Concept

自己從小就喜歡書法，此次作品是隸書臨摹作品，從實際書寫過程中展現隸書的線條美。

I liked calligraphy since I was a child. This work is an imitated seal script, showing its beautiful lines through the writing process.

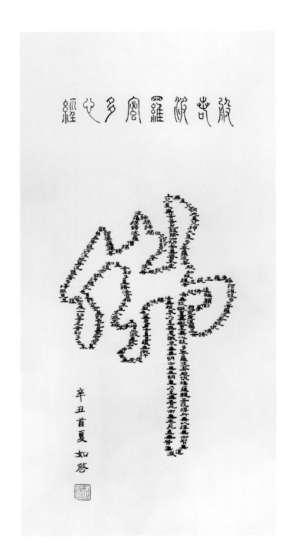

宣紙　書法
Rice Paper - Calligraphy

35×140cm

篆書心經

Heart Sutra in Seal Script

蕭素玲師姑｜馬來西亞／XIAO SU LING｜Malaysia

● 2021 書法金石類 優選獎
Calligraphy and Epigraphy Merit Award

簡　歷｜Profile

長期服務於總本山司庫室。

Long service at the FGS Headquarter Department of Financial Management.

創作理念｜Concept

透過抄寫篆書心經可以去除我們妄念不斷及起伏不定的心，進而修心、靜心，長養耐心和專注力，更希望讓觀看篆書心經的人能升起禪悅法喜之心。

Cleanse our constant delusive and surging mind by copying the *Heart Sutra*. It can cultivate and tranquilize our mind, as well as nurture our patience and concentration. Hope those who view it can elevate the joy of Chan and Dharma in their hearts.

宣紙　書法
Rice Paper - Calligraphy

20×11cm

繪畫類
Painting

蓮・清淨之

Lotus / Pure and Clean

慧堂法師｜臺灣 ／ HUI TANG｜Taiwan

● 2017 繪畫類 佛光獎
 Painting Fo Guang Award

簡　歷 ｜ Profile

現服務於佛光山岡山講堂。曾任總本山寺務監院室法務組。

Currently serving at the Gang Shan Lecture Hall. He has previously served at the Monastery Affairs Department.

創作理念 ｜ Concept

取蓮花清淨之意創作。

Inspired by the purity of lotus flower.

紙本設色
Ink and Color on Paper

45.5x69cm

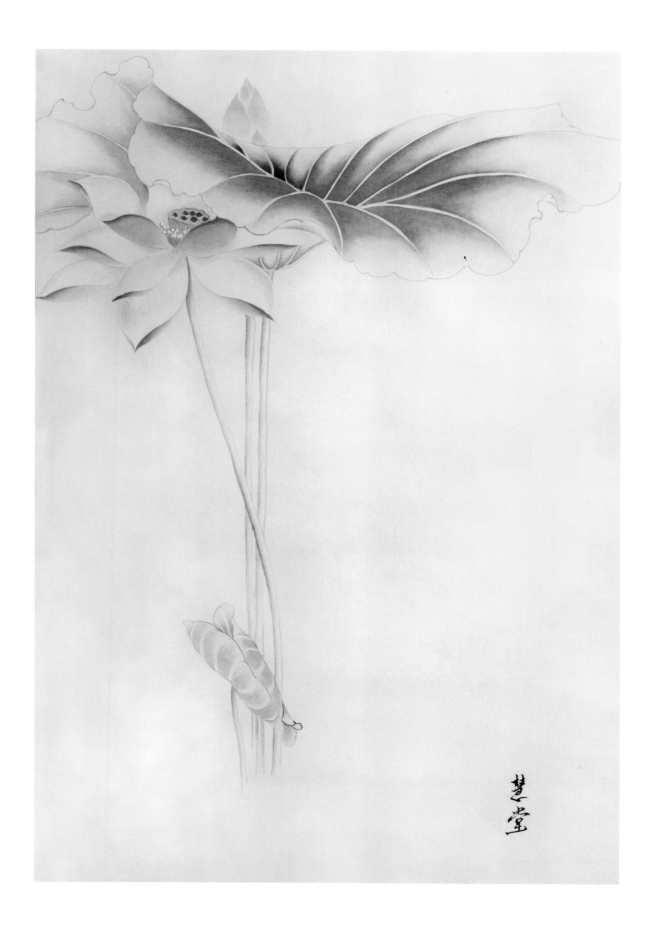

夜晚三昧
Evening Samadhi

知悦法師│美國 ╱ ZHI YUE │ U.S.A

● 2018 動漫影音類 佛光獎
 Anime Video Fo Guang Award

簡　歷 │ Profile

現任佛光山人間佛教研究院國際中心教育培訓組。專長英
語翻譯及講學。

Currently serving at the Institute of Humanistic Buddhism. She is
skilled at English translation and lecture.

創作理念 │ Concept

用不同的角度看世界。畫出內心的世界。

Seeing the world from different angles. Drawing the inner world.

電腦繪圖
Computer Graphics

66x47cm

佛陀紀念館雙閣樓

Twin Pavilions at Buddha Museum

覺紀法師 | 臺灣 ／ JUE JI | Taiwan

● 2018 繪畫類 佛光獎
 Painting Fo Guang Award

簡　歷 | Profile

現任佛光山佛陀紀念館雙閣樓滴水坊主任。擅長典座料理，
曾服務於宜蘭佛光學舍、總本山典座監院室雲居樓等。

Current Chief Executive at the Buddha Museum. Skilled at cooking,
she previously served at Fo Guang Learning Center in Yilan, and the
Cloud Dwelling Building.

創作理念 | Concept

呈現雙閣樓特色，是創作最初的想法，最後以黑白展現其
美。

The original idea of the creation was to showcase the Twin pavilion's
unique features and the final beauty is shown in black and white.

版畫
Engraved Print

83x75cm

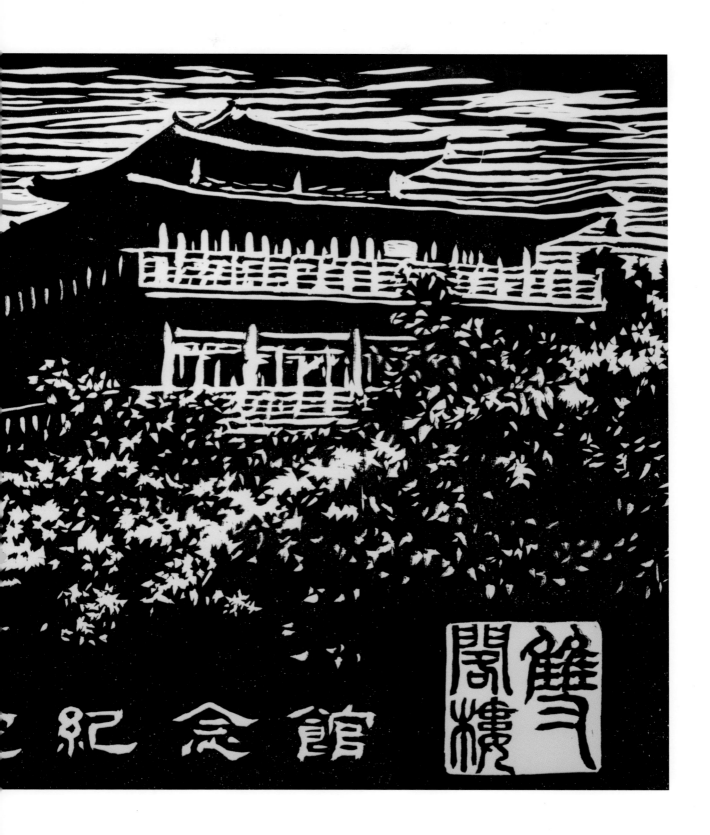

この作品内には「紀念館」と篆書印「雙閣樓」が含まれる。

紀念館

雙閣樓

佛陀成道圖

The Buddha Enlightenment

慧本法師 | 臺灣 ╱ HUI BEN | Taiwan

● 2019 繪畫類 佛光獎
Painting Fo Guang Award

簡　歷 | Profile

現服務於佛光山佛陀紀念館環保組，曾於松山寺、北海道
場等弘法，數十年以環保掃地行行單。

Currently serving at Buddha Museum. He has preached at Songshan
Temple and Beihai Vihara. He has chosen the practice of sweeping the
floor for decades.

創作理念 | Concept

釋迦牟尼發願：「不成正覺，誓不起座」。後於第七日，
夜睹明星悟道，證得無上正等正覺，而成為佛陀。

Shakyamuni Buddha vows never to rise from his seat unless he
achieves Buddhahood. On the seventh day that followed, he was
enlightened by the stars at night, Anuttara-samyak-sambodhi, and
became a Buddha.

紙本設色
Ink and Color on Paper

100x210cm

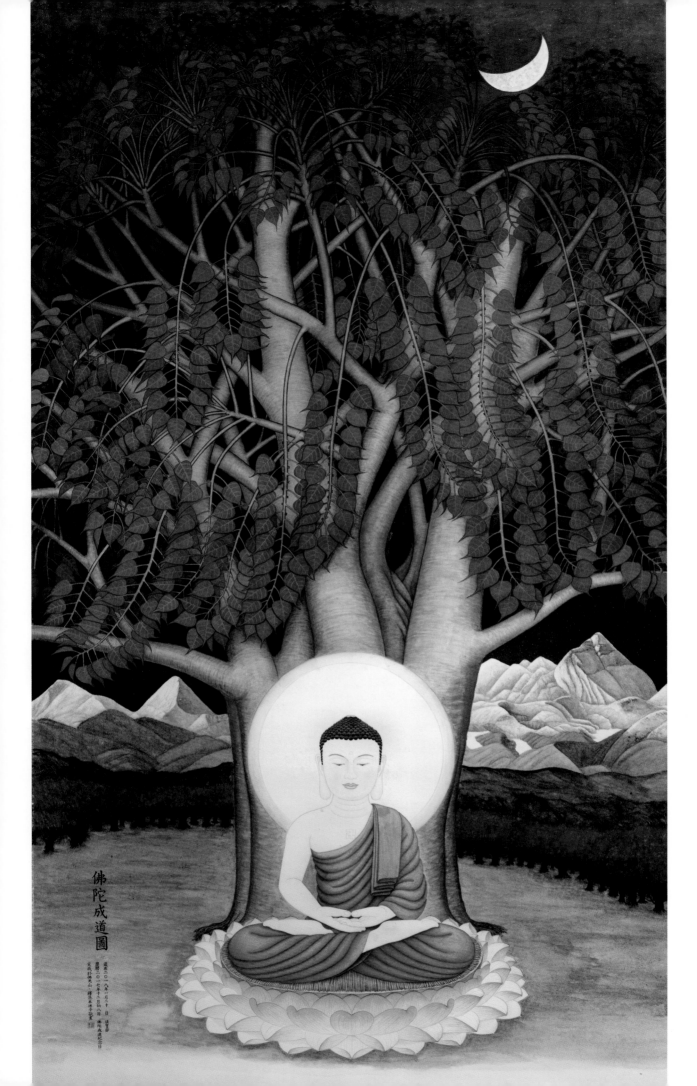

佛陀成道圖

人間佛教
戒定慧學
觀身 36 物

Humanistic Buddhism
The Training of Discipline, Wisdom and Meditation
Contemplation of the 36 Elements in the Body

慧本法師 | 臺灣 ／ HUI BEN | Taiwan

● 2020 繪畫類 佛光獎
Painting Fo Guang Award

簡　歷 | Profile

現服務於佛光山佛陀紀念館環保組，曾於松山寺、北海道場等弘法，數十年以環保掃地行行單。

Currently serving at Buddha Museum. He has preached at Songshan Temple and Beihai Vihara. He has chosen the practice of sweeping the floor for decades.

創作理念 | Concept

觀身 36 物，和（地、水、火、風、空、識）善因緣起、空無自性。

Comtemplating the 36 elements in the body, and its wholesome cause and origination with (earth, water, fire, wind, emptiness, consciousness). Wholesome cause is dependent on origination, and emptiness has no self nature..

紙本設色
Ink and Color on Paper

65.5x131cm

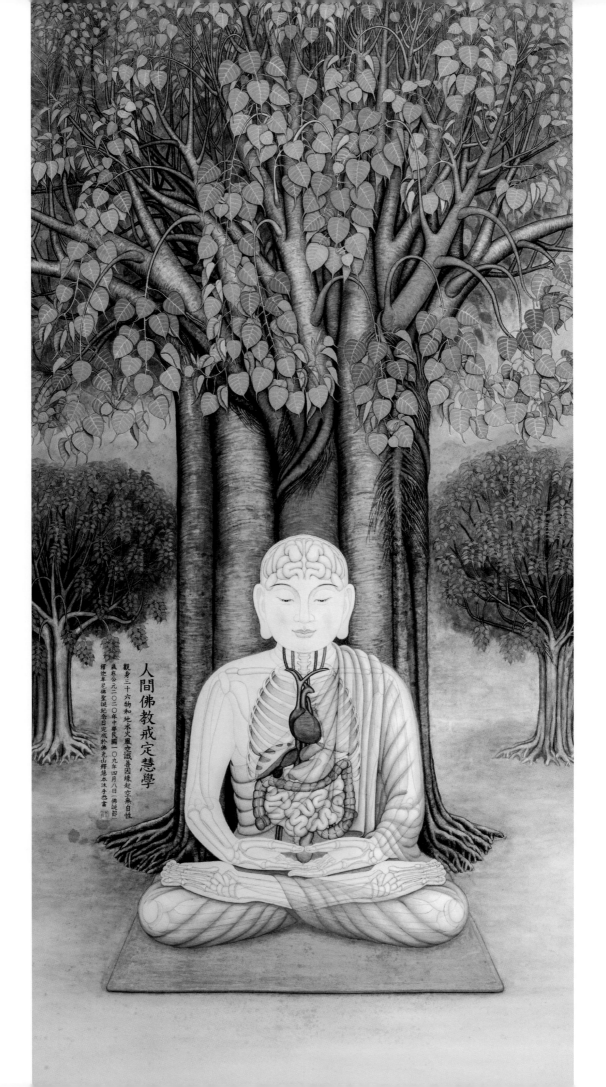

人間佛教戒定慧學

觀身三十六物和地水火風空識普因緣起空無自性

歲在公元二〇二〇年中華民國一〇九年四月八日〔佛誕節〕

釋迦牟尼佛聖誕紀念日定成於佛光山釋慧本沐手恭書

開燈的人
Person Turning On The Light

有正法師｜臺灣 ／ YOU ZHENG｜Taiwan

● 2021 繪畫類 佛光獎
　 Painting Bodhi Award

簡　歷 ｜ Profile

現任佛光山佛陀紀念館法務處雙閣樓人文空間組長。曾服
務於蘭陽別院、佛陀紀念館展覽處等。

Currently serving as Supervisor at Buddha Museum. She has also
served at Nanyang Temple and Exhibition Division of the Buddha
Museum.

創作理念 ｜ Concept

師父上人從小至今弘法都與觀音菩薩有深厚的因緣，師父
也提倡念觀音，拜觀音也要自己做觀音，並提醒「人，不
能沒有慈悲」故佛光山全球五大洲道場在大師的從無至有
中建立，猶如觀音菩薩的化身，隨處救度苦厄。

Venerable Master has a profound affinity with Avalokitesvara since
he was a child. He has also advocated reciting, worshiping, and
practicing of being a Avalokitesvara oneself, reminding "people
to have compassion." Fo Guang Shan's temples around the world
were established from nothingness, just like the incarnation of
Avalokitesvara Bodhisattva. Its mission is to help relieve suffering from
everywhere.

絹本設色
Ink and Color on Silk

100x100cm

持經觀音菩薩
Sutra-holding Avalokitesvara

覺是法師 | 臺灣 / JUE SHI | Taiwan

● 2018 繪畫類 菩提獎
　 Painting Bodhi Award

簡　歷 | Profile

現於佛光山國際佛教促進會，擅接待國際訪客。曾服務於
佛陀紀念館、佛光出版社及派駐日本弘法。

Currently serving at the International Buddhist Progress Society.
Skilled at hosting international visitors, she has previously served at
the Buddha Museum, Fo Guang Publishing House, and stationed in
Japan.

創作理念 | Concept

觀音自在，自在觀音。

Avalokitesvara at ease, with perfect ease is Avalokitesvara.

紙本設色
Ink and Color on Paper

75x172cm

持蓮觀音

Avalokitesvara Holding a Lotus

覺常法師 | 臺灣 ／ JUE CHANG | Taiwan

● 2017 繪畫類 菩提獎
 Painting Bodhi Award

簡　歷 | Profile

現於澳洲佛光山中天寺，曾服務於佛陀紀念館、澳洲南天寺、南／北雪梨佛光緣監寺、墨爾本佛光緣等處。

Currently serving at Chung Tian Temple, Australia. She has previously served at the Buddha Museum, the Nan Tian Temple, and the Fo Guang Yuan Art Gallery in Australia.

創作理念 | Concept

仰望觀音菩薩的大慈大悲，我彷若找到幸福，了知要做自己的貴人。

Aspired by the great mercy of Avalokitesvara, perhaps I have found happiness and finally understood one must become one's own mentor.

紙本設色
Ink and Color on Paper

77x193cm

西方接引阿彌陀佛

Amitabha Buddha in the West

覺昌法師 | 臺灣 ／ JUE CHANG | Taiwan

● 2019 繪畫類 菩提獎
 Painting Bodhi Award

簡　歷 | Profile

現於總本山典座監院室雲居樓餐飲組。曾服務於總本山寺務監院室殿堂組與園藝組等。

Currently serving at the Cloud Dwelling Building. She has previously served at the Monastery Affairs Department.

創作理念 | Concept

「憶佛、念佛、畫佛，當來必定見佛。」畫佛乃為修心結緣，並實踐星雲大師人間佛教的理念。

"By remembering, reciting, and painting the Buddha, you are guaranteed to see the Buddha."Painting the Buddha is for cultivating the mind and creating affinities. It is putting Venerable Master Hsing Yun's theory of Humanistic Buddhism into practice.

紙本設色
Ink and Color on Paper

70x133cm

僧侶的祈願

Sangha's Wishes

有正法師 | 臺灣 ╱ YOU ZHENG | Taiwan

● 2020 繪畫類 菩提獎
 Painting Bodhi Award

簡　歷 | Profile

現任佛光山佛陀紀念館法務處雙閣樓人文空間組長。曾服務於蘭陽別院、佛陀紀念館展覽處等。

Currently serving as Supervisor at Buddha Museum. She has also served at Nanyang Temple and Exhibition Division of the Buddha Museum.

創作理念 | Concept

疫情肆虐，遊客請法師替他在佛前為國外的兒子、行醫的女兒獻燈祈福。

When the epidemic was raging, a tourist asked the venerable to make light offering in front of the Buddha for his son abroad and his daughter serving in the medical field.

紙本設色
Ink and Color on Paper

54x110cm

持蓮觀音

Avalokitesvara Holding A Lotus

慧本法師 | 臺灣 ╱ HUI BEN | Taiwan

● 2021 繪畫類 菩提獎
 Painting Bodhi Award

簡　歷 | Profile

現服務於佛光山佛陀紀念館環保組，曾於松山寺、北海道場等弘法，數十年以環保掃地行行單。

Currently serving at Buddha Museum. He has preached at Songshan Temple and Beihai Vihara. He has chosen the practice of sweeping the floor for decades.

創作理念 | Concept

1. 持連侍佛接引眾生，往生佛剎，蓮池海會蓮花化身。
2. 繼前世正法名如來，乘願再來展現大悲心總持成佛法性。
3. 耳根圓通聞聲救苦，普門示現 32 應化身，教化有情離欲寂靜歡喜安樂。

Holding lotus, attending beside the Buddha, receiving all sentient beings to Buddha's land. After becoming Tathagat in the past, he returned to show great compassion while upholding the dharma nature of enlightenment. Upon hearing the calling to save sufferings, the universal gate manifested thirty-two Avalokiteśvara, teaching sentient beings to be free from desire, attain tranquility and joy.

紙本設色
Ink and Color on Paper

100x210cm

持蓮觀音

歲在公元二〇二一年中華民國一一〇年二月十九日觀世音菩薩聖誕日完成於佛光山
佛光山傳燈會佛畫班邱麗華老師構圖創稿黃怡蓁老師示範指導釋慧本沐手恭畫

23 號沙彌—毛毛蟲
Sramanera No. 23 - Caterpillar

覺具法師 | 臺灣 ╱ JUE JI | Taiwan

● 2017 動漫類 菩提獎
 Anime Bodhi Award

簡　歷 | Profile

現為開山寮監寺。曾服務於佛光山蘭陽別院。擅長典座料
理與教學，並出版有《和星雲大師一起吃飯》一書。

Current Superintendent at Residence of the Founding Master. Skilled
at cooking and teaching, she previously served at Lanyang Temple and
published a book titled, *Having a Meal with Venerable Master Hsing
Yun*.

創作理念 | Concept

因為師父的一筆字，讓我也想創作一筆畫沙彌。簡單的線
條，單純的佛心。製作成 Line 貼圖，希望大家歡喜。

From Master's One-Stroke Calligraphy, I got the idea to create a one-
stroke drawing of sramaneras. I created a series of LINE app stickers
using simple lines. With a pure Buddha's mind, I hope you all enjoy
them.

電腦繪圖
Computer Graphic

38x52cm

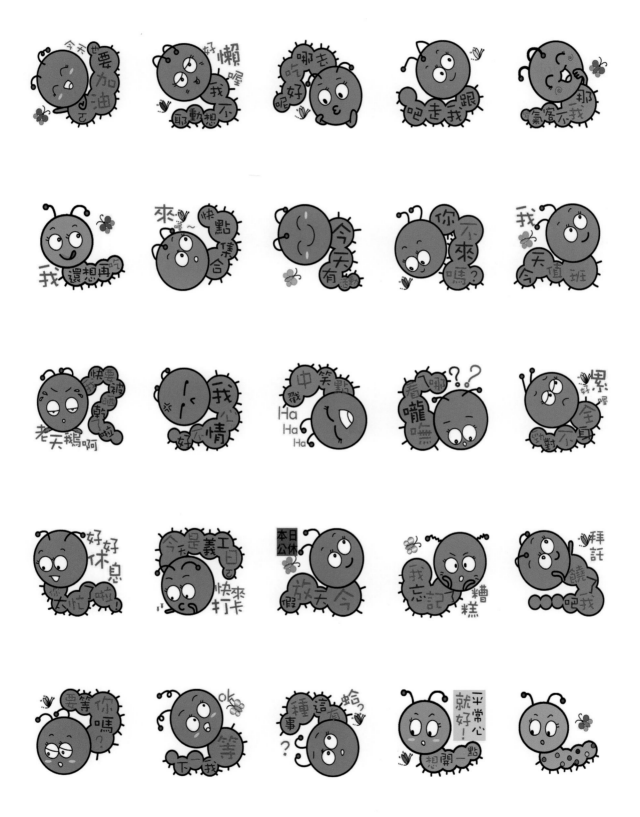

忠義汪來吉
Loyal and Righteous Wong Lai Ji

有宏法師｜馬來西亞 ／ YOU HONG｜Malaysia

● 2018 動漫影音類 菩提獎
　 Anime Video Bodhi Award

簡　歷｜Profile

現於澳洲佛光山尔有寺職事。曾於澳洲佛光山南天寺及佛光出版社、萬壽園、電視中心等服務。

Currently serving at the Buddhist Temple in Australia. She has previously served at Nan Tien Temple, Buddha's Light Publishing, Longevity Memorial Park, and FGS TV Center.

創作理念｜Concept

世界最美是有彩色。故作品在色系上用心的調和，令人看了會感覺很溫暖很開心，有療癒的作用。呈現佛光山人間佛教三好四給的精神。

The most beautiful color in the world is presenting the spirit of Fo Guang Shan's Humanstic Buddhism of Three Goodnesses and Four Givings in warm and healing colors.

電腦繪圖
Computer Graphic

81x85cm

生死自如

The Endless Cycle of Life and Death with Ease

妙詮法師 | 臺灣 ╱ MIAO JUAN | Taiwan

● 2017 動漫類 般若獎
Anime Prajna Award

簡　歷 | Profile

現於佛光山佛陀紀念館法務處。曾服務於圓福寺、南華學館、普門寺等。

Currently serving at Dharma Service Division of the Buddha Museum. She has previously served at Yuan Fu Temple, Nanhua Learning Center, and Pu Men Vihara.

創作理念 | Concept

根據大師著作《星雲禪話》內容，繪製四格漫畫，呈現故事禪機。

Based on the content of Venerable Master's book, *Hsing Yun's Chan Stories*, the story of the Chan allegory was presented through the drawing of a four-framed comic strip.

水彩
Watercolor

29.7x21cm

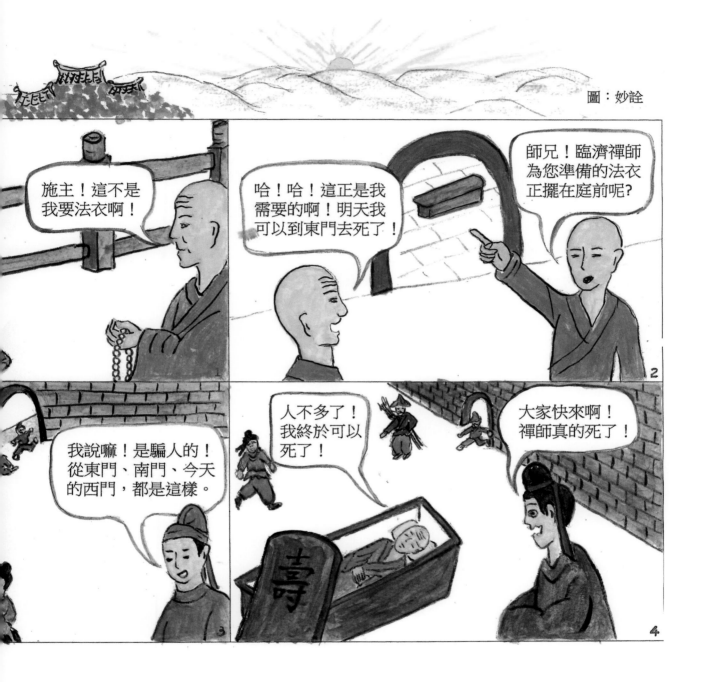

圖：妙詮

空無人生
Emptiness of Life

道悟法師｜臺灣 ／ DAO WU｜Taiwan

● 2017 繪畫類 般若獎
Painting Prajna Award

簡　歷 | Profile

現於總本山傳燈樓客堂知客。曾派駐馬來西亞與大陸弘法，及服務於普門雜誌社、覺世旬刊。

Currently serving as Receptionist at the Dharma Transmission Center. She has previously preached in Malaysia and Mainland China. She has also served at *Pu-Men Magazine* and *Awakening the World Periodical*.

創作理念 | Concept

藉由插畫傳播星雲大師法語，弘揚人間佛教。

Promoting Venerable Master Hsing Yun's Dharma words and Humanistic Buddhism through illustrations.

色鉛筆
Colored Pencil

42x29.7cm

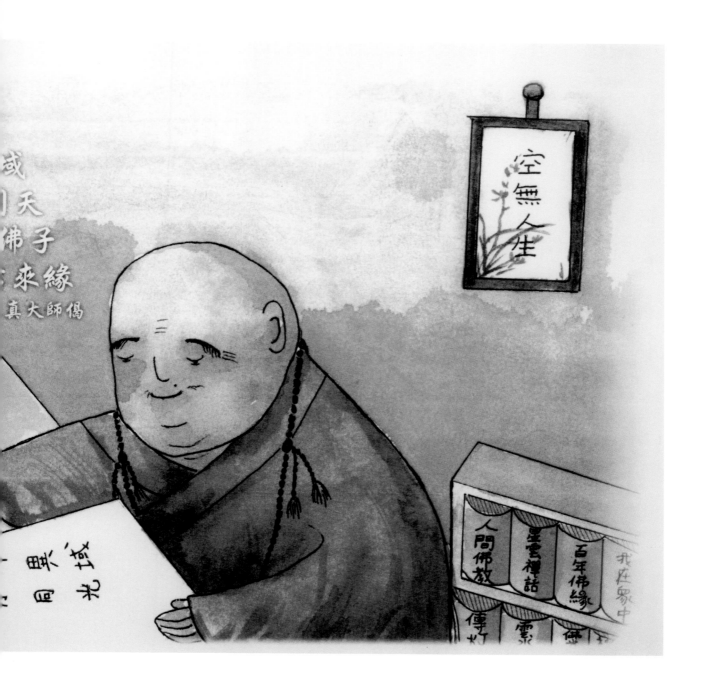

初夏

Early Summer

慧堂法師│臺灣 ╱ HUI TANG │ Taiwan

● 2018 繪畫類 般若獎
Painting Prajna Award

簡　歷 │ Profile

現服務於佛光山岡山講堂。曾任總本山寺務監院室法務組。

Currently serving at the Gang Shan Lecture Hall. He has previously served at the Monastery Affairs Department.

創作理念 │ Concept

春夏節氣的交替，一如生命境遇的轉換，以熱情面對、成就自我。當下即是。

The alternation of the spring and summer time is like the transformation of life circumstances, with enthusiasm for self-achievement in the present moment.

紙本設色
Ink and Color on Paper

42x29.7cm

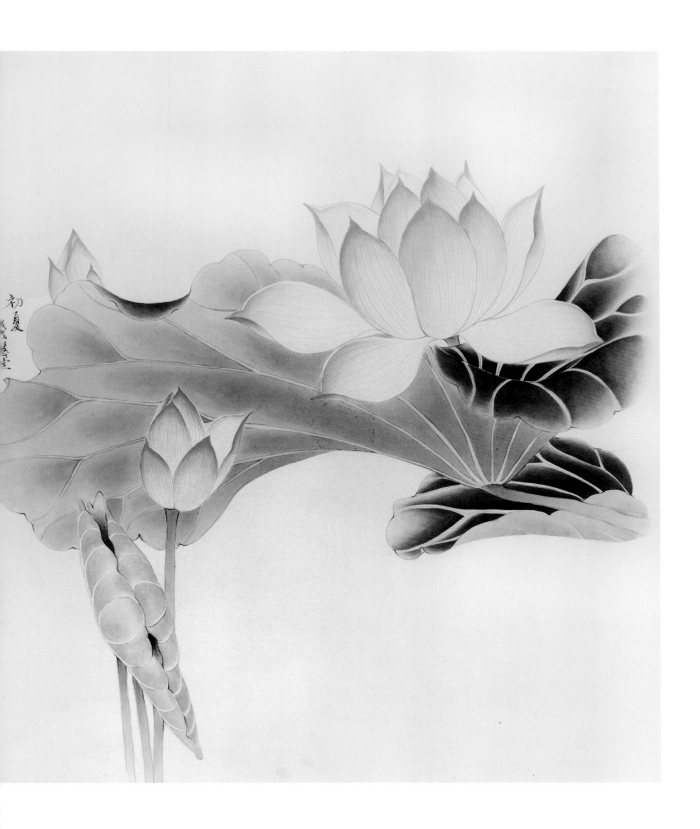

人間佛教
Humanistic Buddhism

妙念法師｜臺灣 ╱ MIAO NIAN｜Taiwan

● 2020 **繪畫類 般若獎**
 Painting Prajna Award

簡　歷｜Profile

現任澎湖佛光山信願寺監寺。曾服務於大明寺等臺灣別分院道場。

Currently serving as Superintendent of FGS Sin Yuan Temple in Penghu. She has previously served at Da Ming Temple and FGS branch temples in Taiwan.

創作理念 │ Concept

藉仿敦煌石窟彌勒說法圖、篆刻心經，小沙彌的修行生活，
呈現出歡喜的佛光淨土。

Presenting a joyful Buddha's light pureland by adopting pictures from
the Maitreya mural in the Dunhuang Caves, engravings from the *Heart
Sutra*, and daily practices of the sramaneras.

篆刻・水彩
Seal Engraving / Watercolor

138x69cm

讀書啦！書香森友會！
Reading Crossing!

知恩法師 | 臺灣 ／ ZHI EN | Taiwan

● 2021 繪畫類 般若獎
 Painting Prajna Award

簡　歷 | Profile

現服務於總本山都監院資訊中心，曾於佛光山佛陀紀念館、信眾監院室等弘法。

Currently serving at the Information System Center. She has previously served at the Buddha Museum, Public Services Department, etc.

創作理念 | Concept

有國際森林博物館美譽的佛陀紀念館年年在詩意盎然的秋季舉辦國際書展，在自然生態環繞與各種動物跟大佛的陪伴閱讀，如同暖陽讓孩子身心靈都能在正能量的包圍下達到啟蒙。

The Buddha Museum has been recognized as an International Forest Museum. It holds an international book fair every year. Surrounded by natural ecologies, various animal habitats, and the Great Buddha, like the warm rays from sunlight, children can attain enlightenment under the welcoming embrace of these positive energies.

電腦繪圖
Computer Graphic

42x59.4cm

我是佛

I am Buddha

慧裴法師｜馬來西亞 ╱ HUI PEI｜Malaysia

● 2019 繪畫類 優選獎
 Painting Merit Award

木．烙燒
Wood Pyrograph

46.6×30.5cm

簡　歷 ｜ Profile

現任總本山都監院院長助理。曾任佛光山叢林學院男
眾學部主任、佛光大學佛教學系職事。

Current Assistant to the President of Executive Council. He
has also served as the Dean of FGS Tsung Lin University and
worked at Fo Guang University.

創作理念 ｜ Concept

「朝朝共佛起，夜夜伴佛眠」。佛在我心，久了，我
們也被雕塑成一尊佛。

"Awake to the Buddha, Asleep with the Buddha. "The Buddha
is always on my mind. After a long time, we are sculpted into a
Buddha.

我的師父
My Master

慧裴法師｜馬來西亞 ／ HUI PEI｜Malaysia

● 2020 繪畫類 優選獎
　Painting Merit Award

創作理念 ｜ Concept

他是佛教的改革者及佛法的實踐者，是我一生追隨效法的
—星雲大師。

He is a Buddhist reformer and a practitioner of Dharma. Venerable
Master Hsing Yun is someone that I have followed as an example my
whole life.

木・烙燒
Wood Pyrograph

48x68.5cm

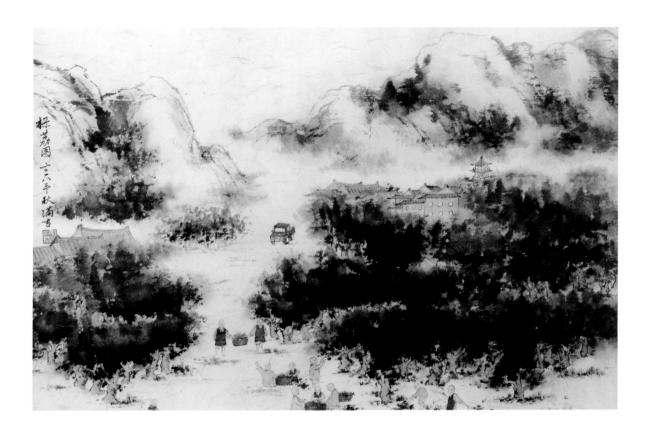

出坡採荔

Collecting Litchi at Chorework

滿吉法師 | 臺灣 ╱ MAN JEE | Taiwan

● 2019 繪畫類 優選獎
Painting Merit Award

簡 歷 | Profile

現任宗務堂檔案室主任。曾服務於佛光淨土文教基金會及臺灣別分院道場等。

Currently serving as Board Director at the Office of Religious Affairs. She previously served at the Pure Land Cultural & Educational Foundation as well as other branch temples in Taiwan.

創作理念 | Concept

懷念早期全山大眾出坡採荔枝的歡樂時光，故以畫記載。

Reminiscing the joyful times when the assembly of the entire temple went to pick lychees as chorework in the early days, as documented in the painting.

紙本設色
Ink and Color on Paper

65.5×50cm

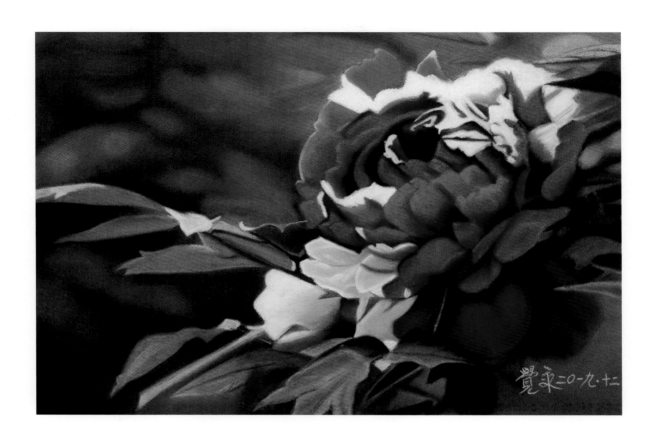

富貴花開

Blooming Flowers Bring Prosperity

覺乘法師 │ 臺灣 ╱ JUE CHENG │ Taiwan

● 2020 繪畫類 優選獎
　Painting Merit Award

簡　歷 │ Profile

現任佛光山惠中寺知客主任。曾擔任妙法寺、草屯禪淨中心等監寺。

Current Deputy Executive at Hui Chung Temple. She has previously served as the Superintendent of Miao Fa Temple, Hui Chung Temple, and Caotun Meditation Center, etc.

創作理念 │ Concept

彩繪人生，增添色彩，豐富生活。

Painting life, adding colors and enriching life.

粉彩
Pastel

56×74cm

空寂
Emptiness

覺紹法師│臺灣 ╱ JUE SHAO │ Taiwan

● 2020 繪畫類 優選獎
 Painting Merit Award

簡　歷│Profile

現任國際佛光會中華總會財務主任。曾任佛光大學會計、佛光大學董事會職事。

Current Deputy Executive at BLIA Chunghwa Headquarters. She has previously served at Fo Guang University.

創作理念│Concept

透過畫作，展現禪心禪意，闡述禪師空寂之意境。

The painting is an illustration of Chan mind and concept. It also expounds the mood of a Chan master's journey into emptiness.

壓克力彩
Acrylic Color

32.8×24cm

欲尋
Intend to Search

有廉法師｜臺灣／YOU LIAN｜Taiwan

● 2020 **繪畫類 優選獎**
 Painting Merit Award

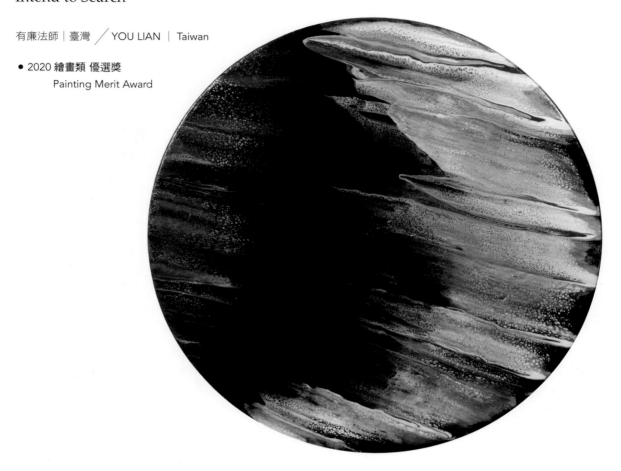

簡 歷｜Profile

現於佛光山桃園講堂。曾服務於旗山禪淨中心、總本山寺務監院室園藝組與法務組等。

Currently serving at Taoyuan Lecture Hall. She has also served at the Qishan Buddhist Center as well as the Monastery Affairs Department.

創作理念｜Concept

時間與空間再 ＋ 一個我；畫布與顏料再 ＋ 一個我；水與油還有我；慢著品～？我在哪？。

Time, space and me; canvas, paint and me; water, oil and me; take your time to savor it...... Where am I?

複合媒材
Mixed Media

直徑 60cm

尋找禪心
Searching for Chan's Mind

覺因法師 | 臺灣 / JUE YIN | Taiwan

● 2019 繪畫類 優選獎
 Painting Merit Award

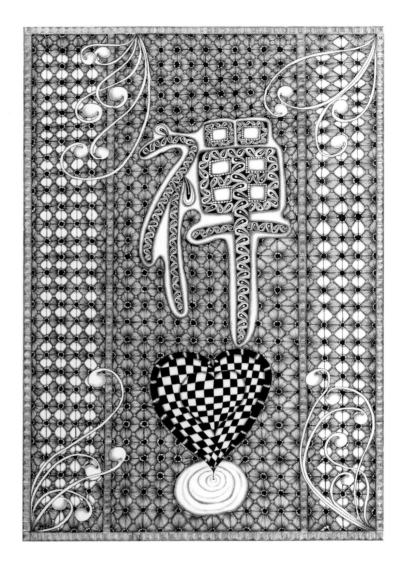

簡 歷 | Profile

現為佛光山安國寺職事。曾服務於慧慈寺。

Currently serving as staff at An Guo Temple. She has also previously served at the Hui Chi Temple.

創作理念 | Concept

畫宗教與藝術的融和；人安止於佛道禪心中。

Painting the harmonious blending of religion with art. People become calm in the mind through Buddhism, Taoism and Chan.

代針筆
Technical Pen

73×98cm

禪繞延伸藝術
Arts of Zentangle Extend

覺因法師 | 臺灣 ／ JUE YIN | Taiwan

● 2020 繪畫類 優選獎
 Painting Merit Award

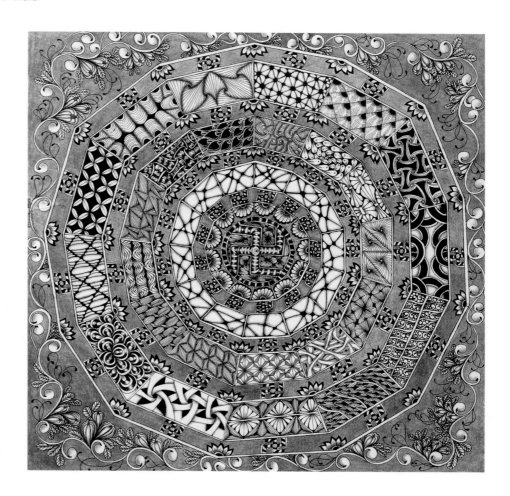

創作理念 | Concept

以畫攝心。規律的筆畫構圖，一枝筆、一張紙，創造
獨一無二之美。

To concentrate by painting. It is a creation of unique aesthetics
through the composition of regular strokes, one pen and a
piece of paper.

代針筆
Technical Pen

56×56cm

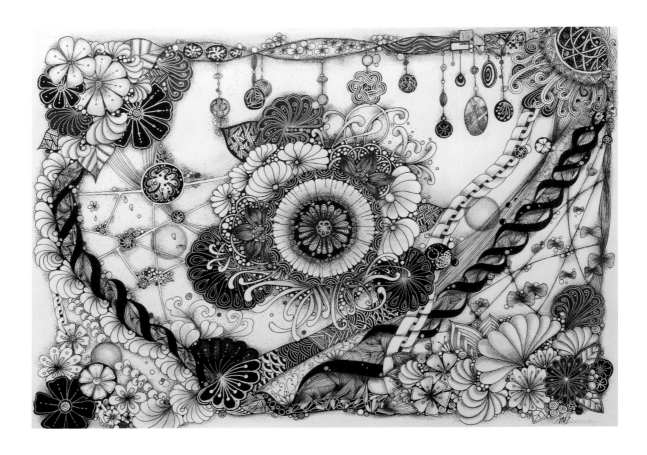

原點

Orgin

妙根法師｜臺灣／MIAO GEN｜Taiwan

● 2020 **繪畫類 優選獎**
 Painting Merit Award

代針筆 ・ 鉛筆 ・ 色鉛筆
Technical Pen・Pencil・Colored Pencil

53.4×38.8cm

簡　歷 ｜ Profile

現任滴水坊總部主任。曾於佛光山大明寺、極樂寺等
別分院道場弘法。

Currently serving as Deputy Executive of Waterdrop Tea
House Head Office. She has served at Da Ming Temple, Chi Le
Temple, and FGS branch Temples.

創作理念 ｜ Concept

回歸純粹的原點，每一筆都可以創造出獨特的美麗世
界。

Returning to the pure origin, every stroke can create a unique
and beautiful world.

菩提
Bodhi

妙根法師｜臺灣 ／ MIAO GEN｜Taiwan

● 2021 **繪畫類 優選獎**
　Painting Merit Award

創作理念 ｜ Concept

回歸純粹的原點－禪繞的世界沒有錯誤，每一筆都可以創
造出唯一的美麗世界。

Regress to the pure origin, there is no mistake in the world of
Zentangle. Every stroke can create an unique and beautiful world.

代針筆 ・ 鉛筆 ・ 色鉛筆
Technical Pen・Pencil・Colored Pencil

38.8×53.4cm

彩繞禪趣

The Fun of Colored Zentangle

妙振法師 | 臺灣 ╱ MIAO ZHEN | Taiwan

● 2019 繪畫類 優選獎
 Painting Merit Award

簡　歷 | Profile

現於蘭陽仁愛之家。曾服務於首爾佛光山寺、女眾傳燈會、國際佛光會中華總會。

Currently serving at Lanyang Ren Ai Senior Citizen's Home. She has served at the Seoul Fo Guang Shan Temple, the Sangha Affairs Committee, and BLIA.

創作理念 | Concept

隨心而作。

Followed my own mind to create.

色鉛筆
Colored Pencil

36.4× 25.7cm

吉祥三色堇

Auspicious Viola Tricolor

妙麟法師 | 臺灣 ／ MIAO LIN | Taiwan

● 2019 繪畫類 優選獎
　Painting Merit Award

簡　歷 | Profile

現任佛光山佛陀紀念館知客室外事主任。曾任鳳山講堂、惠中寺、妙法寺、大林講堂等監寺。

Current Deputy Executive at Buddha Museum. She has previously served at the Fongshan Lecture Hall, Hui Chung Temple, Miao Fa Temple, Dalin Lecture Hall, etc.

創作理念 | Concept

花開四季多美麗！以此祝福花開見佛，佛道圓滿。

How beautiful the flowers bloom throughout four seasons! With this blessing, may one see the Buddha when the flowers bloom, and fullfill one's Buddhahood.

膠彩
Eastern Gouache

34.8×27.3cm

南無大慈大悲救苦救難
廣大靈感觀世音菩薩
歲在戊戌立夏弟子輝妙麟恭繪

慈悲應化觀世音

Compassionate Transformation of Avalokitesvara Bodhisattva

妙麟法師 ∣ 臺灣 ／ MIAO LIN ∣ Taiwan

● 2020 繪畫類 優選獎
　　Painting Merit Award

紙本設色
Ink and Color on Paper

141×143cm

創作理念 ∣ Concept

聞聲救苦觀世音，善財龍女隨侍旁；祥龍護法心歡喜，
清淨莊嚴如淨蓮。

Compassionate Avalokitesvara is attended by attendants on her sides. The Dharma protectors are as joy and solemn as lotus flowers.

祥和寧靜 · 金佛

Auspicious and Peaceful Budda

妙麟法師｜臺灣 ／ MIAO LIN｜Taiwan

● 2021 繪畫類 優選獎
　 Painting Merit Award

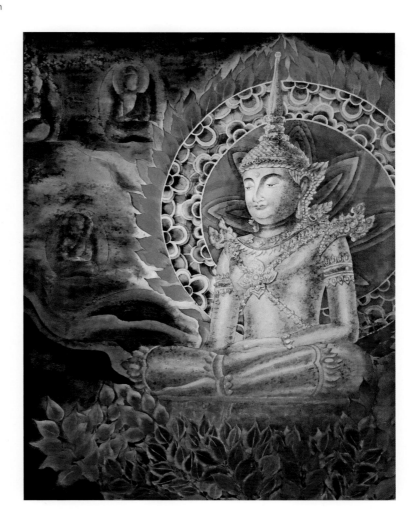

紙本設色
Ink and Color on Paper

79×105cm

創作理念 ｜ Concept

金佛殿的泰國金佛，象徵南北傳佛教融合的文化，慈悲、祥和與寧靜，讓人心生歡喜，佛的頭光與身光以菩提葉為裝飾，呈火燄色，菩提葉在金剛座旁，象徵菩提樹下證悟成就佛道。

The Golden Buddha represents the fusion of Buddhism from the North and the South, compassion, peace and tranquility filled people with delight. The Buddha's halo and aureole are decorated with Bodhi leaves next to the diamond throne. It symbolized the Buddha's attainment of enlightenment under the Bodhi tree.

出水浮蓉

Lotus Flowers Surface above Water

妙瑋法師 | 臺灣 ／ MIAO WEI | Taiwan

● 2019 繪畫類 優選獎
 Painting Merit Award

簡　歷 | Profile

現任佛光山斗六禪淨中心監寺。曾服務於台南講堂等臺灣別分院道場。

Currently serving as the Superintendent of Douliu Meditation Center. She has previously served at the Tainan Lecture Hall and FGS branch temples in Taiwan.

創作理念 | Concept

感謝常住給徒眾因緣。以拙作參展，因眾中有我。

Gratitude to the monastery for the affinity to the disciples. Submitting my work to participate because among the many, there I am.

紙本設色
Ink and Color on Paper

82×52.3cm

似花非花

Similar to Flower, but is not a Flower

妙貫法師｜臺灣 ／ MIAO GUAN｜Taiwan

● 2020 繪畫類 優選獎
　Painting Merit Award

壓克力彩
Acrylic Color

20×20cm

簡　歷｜Profile

現於佛光大藏經編藏處。曾服務於總本山信眾監院室行政組、佛教研修學院、文化院等。

Currently serving at the Buddhist Canon Research Department. She has also served at the Public Service Department and the Culture Council, etc.

創作理念｜Concept

色彩流動，無我無畫。似畫非畫，似花非花。似鳶尾、若藍蝶，歡喜結緣。

Colors are flowing. There is no self and no painting. Resembling painting but is not a painting. Resembling flower but is not a flower. It is like an iris, a blue butterfly, developing affinities in joy.

大日如來
Vairocana

覺鴻法師 ｜臺灣 ／ JUE HUNG ｜ Taiwan

● 2019 繪畫類 優選獎
　 Painting Merit Award

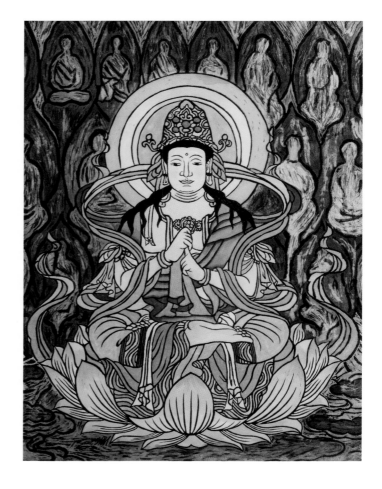

簡　歷 ｜ Profile

現任佛光山南台別院監院。曾服務於國際佛光會中華總會，及派駐臺灣與香港道場弘法。

Current Superintendent of Nan Tai Temple. She has previously served at the BLIA Chunghwa Headquarters and has been stationed at Taiwan and Hong Kong.

創作理念 ｜ Concept

莊嚴的大日如來、精進修行的菩薩。線條展現傳統版畫刀刻韻味。

The solemn Mahavaircana, a bodhisattva diligenty in practice. The lines show the charm of traditional printmaking.

紙本設色
Ink and Color on Paper

47×65cm

菩薩像

Portrait of Bodhisattva

妙昭法師｜臺灣 ／ MIAO ZHAO｜Taiwan

● 2020 繪畫類 優選獎
　Painting Merit Award

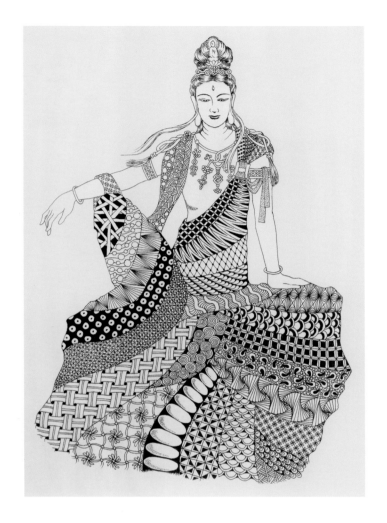

簡　歷 ｜ Profile

現於佛光山寶塔寺，曾服務於惠中寺及負責佛光緣美
術館台中館、普門寺、佛陀紀念館等。

Currently serving at Bao Ta Temple. She has previously served
at Hui Chung Temple and overlooks Taichung Fo Guang Yuan
Art Gallery, Pu Men Vihara and Buddha Museum.

創作理念 ｜ Concept

以禪繞畫為主題的菩薩像。

Using Bodhisattva as the theme of Zentangle art.

針筆
Technical Pen

29.7×42cm

金剛經經變圖

Sutra Illustration of Diamond Sutra

有正法師｜臺灣／YOU ZHENG｜Taiwan

● 2019 繪畫類 優選獎
　　Painting Merit Award

簡　歷｜Profile

現任佛光山佛陀紀念館法務處雙閣樓人文空間組長。
曾服務於蘭陽別院、佛陀紀念館展覽處等。

Currently serving as Supervisor at Buddha Museum. She has
also served at Nanyang Temple and Exhibition Unit of the
Buddha Museum.

創作理念｜Concept

為感受古德信仰之虔心，以臨摹經變圖體驗之。

Through copying of sutra illustrations, the experience enabled
me to feel the devotion of ancient sage's faith.

紙本設色
Ink and Color on Paper

33×26cm

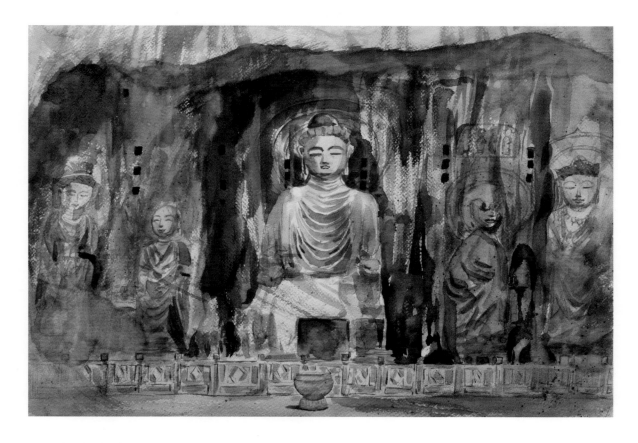

恆時說法處

The Place of Constantly Teaching the Dharma

有容法師 | 臺灣 ╱ YOU RONG | Taiwan

● **2020 繪畫類 優選獎**
Painting Merit Award

簡　歷 | Profile

現任國際佛光會中華總會副祕書長。曾任國際佛光會世界總會亞洲辦事處辦公室主任、人間福報中區辦公室主任等。

Currently serving as Deputy Secretary General of BLIA Chunghua Headquarters. She has served at the BLIA Asia Regional Office and *The Merit Times*.

創作理念 | Concept

將最感動、深刻與歡喜的，以色彩層層堆疊；如同法水層層澆灌。

Piling layers of the most touching, profound and joyful colors on top of each other just like watering the Dharma layer upon layer.

水彩
Watercolor

54×39cm

藥師琉璃光如來
Medicine Buddha

妙貫法師｜臺灣 ／ MIAO GUAN｜Taiwan

● 2021 繪畫類 優選獎
 Painting Merit Award

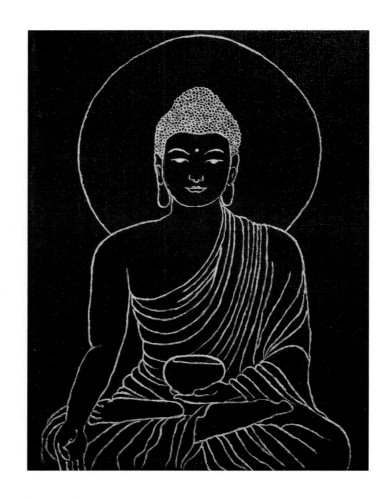

壓克力彩
Acrylic Color

30×40cm

簡　歷｜Profile

現於佛光大藏經編藏處。曾服務於總本山信眾監院室
行政組、佛教研修學院、文化院等。

Currently serving at the Buddhist Canon Research Department.
She has also served at the Public Service Department, the
Culture Council, etc.

創作理念｜Concept

時值疾疫猖行，災苦連連，故發願虔敬恭繪此「藥師
琉璃光如來」像，願祈眾殃消彌、災難蠲除，希藉由
此全程跪伏所繪之佛像，仰仗藥師如來本願，令見聞
者健康平安。

Making a vow to paint this "Medicine Buddha" portrait at the
rampant time of the epidemic with the wish that all disasters
will be eliminated. Relying on the Medicine Buddha's powers to
help us, I painted the Buddha, kneeling on my knees the entire
process. Wish for all witnesses to be healthy and safe.

思維觀音
Thinking Avalokitesvara

覺昌法師 | 臺灣 ╱ JUE CHANG | Taiwan

● 2021 繪畫類 優選獎
Painting Merit Award

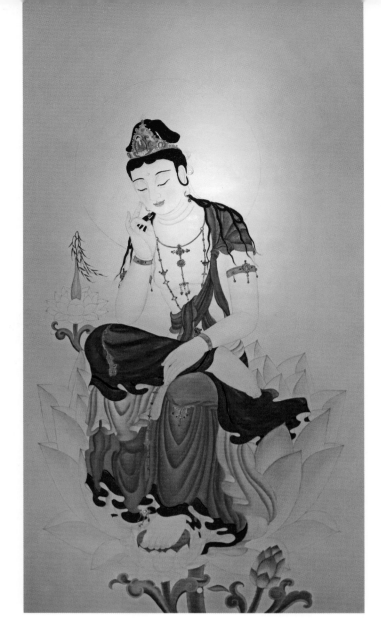

簡　歷 | Profile

現於總本山典座監院室雲居樓餐飲組。曾服務於總本山寺務監院室殿堂組與園藝組等。

Currently serving at the Cloud Dwelling Building. She has served at the Shrine Unit and Landscaping Unit of Monastery Affairs Department.

創作理念 | Concept

佛化的藝術莊嚴可以度化有情，自利利他的一門修心法門，從中獲得無盡的法喜。實踐師傅上人推動人與佛教的理念。以藝術弘法示我一份小小的願心。

The solemn Buddhism art can save sentient beings from emotions, self-serving thoughts. It is a teaching of cultivating the mind while gaining endless Dharma joy. Practicing Venerable Master's philosophy of promoting Humanistic Buddhism, it is my wish to propagate the Dharma through art.

水彩
Watercolor

66×131cm

禪藏在你我之間—想當然爾
Chan Canon between You and Me - Most Certainly

道悟法師 | 臺灣 ／ DAO WU | Taiwan

● 2019 繪畫類 優選獎
 Painting Merit Award

簡　歷 | Profile

現為總本山傳燈樓客堂知客。曾派駐馬來西亞與大陸弘法，及服務於普門雜誌社、覺世旬刊。

Currently serving as Receptionist at the Dharma Transmission Center. She has previously preached in Malaysia and Mainland China. She has also served at *Pu-Men Magazine* and *Awakening the World Periodical*.

創作理念 | Concept

取材於星雲大師的語錄，以漫畫來呈現。

Based on the Venerable Master Hsing Yun's teachings and presented in the format of comics.

色鉛筆
Colored Pencil

126×87cm

（局部）

星雲禪話一家親

Hsing Yun's Chan Stories - Everyone is Family

有宏法師｜馬來西亞　／　YOU HONG｜Malaysia

● 2019 繪畫類 優選獎
　Painting Merit Award

電腦繪圖
Computer Graphics

84.1×118.9cm

簡　歷｜Profile

現於澳洲佛光山尔有寺職事。曾於澳洲佛光山南天寺，及佛光出版社、萬壽園、電視中心等服務。

Currently serving at the Buddhist Temple in Australia. She has previously served at Nan Tien Temple, Buddha's Light Publishing, Longevity Memorial Park, and FGS TV Center.

創作理念｜Concept

禪門公案，依文字表象不易理解。故以漫畫圖文闡述一則一則的「星雲禪話一家親」。

Chan Monastery Gongans cannot be easily understood just by words. Therefore, "Hsing Yun's Ch'an Talk - Everyone is Family" is illustrated by comic strips with pictures and texts.

不動明王
Acalanatha Vidyrraja

知天法師 | 馬來西亞 ╱ ZHI TIAN | Malaysia

● 2019 繪畫類 優選獎
　 Painting Merit Award

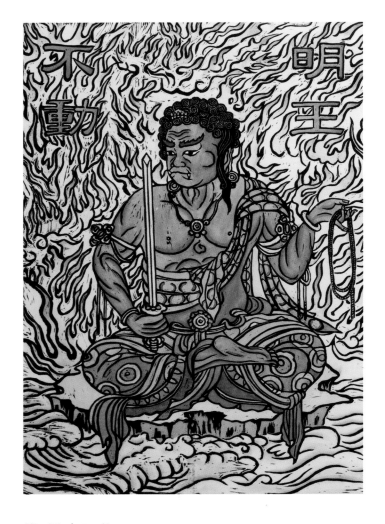

簡　歷 | Profile

現任佛光山南台別院社教監院。曾任佛光緣美術館台南館輔導法師等。

Currently serving as Department Head of Social Education at Nan Tai Temple. She has also served as the Guiding Venerable of Tainan Fo Guang Yuan Art Gallery.

創作理念 | Concept

面對修道上的煩惱，要學習不動明王。安忍不動，安住當下。

When faced with defilements from cultivation, learn from Acalanatha Vidyrraja's unwavering patience while abiding to here and now.

紙本設色
Ink and Color on Paper

47 × 65cm

地藏菩薩
Ksitigarbha Bodhisattva

蕭素玲師姑｜馬來西亞／XIAO SU LING｜Malaysia

● 2020 繪畫類 優選獎
 Painting Merit Award

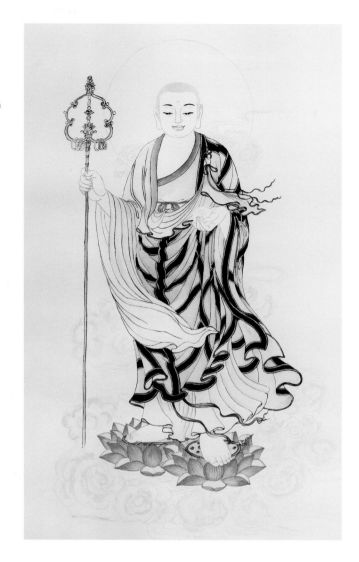

簡　歷 ｜ Profile

長期服務於總本山司庫室。

Long service at the FGS Headquarter Department of Financial Management.

創作理念 ｜ Concept

透過畫佛畫培養禪定與專注力。

Practicing meditation and concentration through the creation of Buddha paintings.

紙本設色
Ink and Color on Paper

41× 67cm

自在觀音
Carefree Avalokitesvara

如康法師 ｜ 臺灣 ／ RU KANG ｜ Taiwan

● **2021 繪畫類 優選獎**
 Painting Merit Award

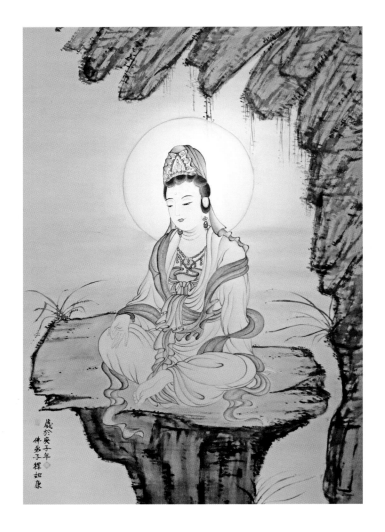

簡　歷 ｜ Profile

現任佛光山極樂寺。曾服務於蘭陽別院道場弘法。

Currently serving at Jile Temple. She has previously served at the Lanyang Temple.

創作理念 ｜ Concept

想藉由一筆一畫的畫作，畫出心中菩薩莊嚴法相。過程中不斷提筆練習揣摩，八識種子湧現各種的畫。成品完成是獨特性，裡面的因緣是歡喜、自信、 沉穩。更多的是畫菩薩的恭敬心。

Drawing the solemn image of the Bodhisattva in my mind one stroke at a time. I keep practicing and various paintings emerged from the seeds of the eight consciousness. This work is unique. The affinity that lies within is that of joy, self-confidence, calmness, and a respectful mind of the Bodhisattva.

紙本設色
Ink and Color on Paper

51.5× 78.6cm

師父

Venerable Master

知榮法師 ｜ 馬來西亞 ／ ZHI RONG ｜ Malaysia

● 2021 繪畫類 優選獎
　Painting Merit Award

簡　歷 ｜ Profile

現服務於佛光山員林講堂，曾於國際佛光會中華總會
及派駐菲律賓等弘法。

Currently serving at the Yuanlin Lecture Hall. She has preached
at BLIA Chunghwa Headquarters, dispatched to the Philippines,
etc.

創作理念 ｜ Concept

希望能更看清楚師父。
出家的時候，師父已經身體沒有很好，很少有機會接觸。

Hope to see the Master more clearly.
When I became ordained as a nun, Master was already in poor
health so I hardly have a chance to spend time with him.

炭筆
Charcoal Pencil

39 × 54cm

百花盛開・太子降誕

Full of Blooming Flowers / Birth of Prince Siddartha

如承法師｜臺灣 ／ RU CHENG｜Taiwan

● 2021 繪畫類 優選獎
 Painting Merit Award

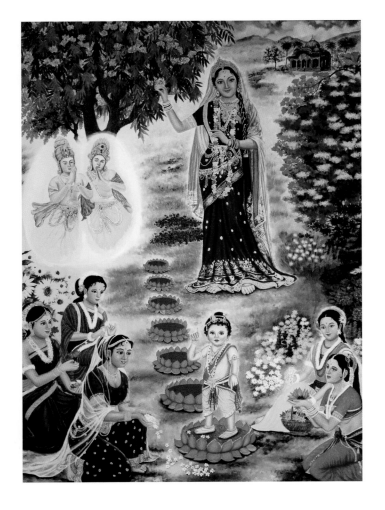

簡　歷｜Profile

長期服務於人間福報。

Long serving at *The Merit Times*.

創作理念｜Concept

2600 年前，印度迦毗羅衛國的悉達多太子在藍毗尼園降誕時的殊勝事蹟。摩耶夫人回娘家待生產，途中行經藍毗尼園，園中百花齊放，行至無憂樹下，誕生了悉達多太子。

Prince Siddhartha was born at the Lumbini Garden in India. It was an extraordinary deed some 2600 years ago. When Queen Maya returned to her mother's house to give birth, she passed by the Lumbini Garden with flowers blossoming all around. As she walked under the Ashoka tree, Prince Siddhartha was born.

壓克力彩
Acrylic Color

90× 110cm

守護淨土
Protect Pure Land

妙淨法師 | 加拿大 ╱ MIAO JING | Canada

● 2021 繪畫類 優選獎
　Painting Merit Award

簡　歷 | Profile

現任菲律賓佛光山萬年寺住持、佛光緣美術館馬尼拉
館館長。

The Presiding Abbess of FGS Mabuhay Temple, and is serving
as Board Director at Fo Guang Yuan Manila Art Gallery.

創作理念 | Concept

在佛陀紀念館大佛座下植樹，人們用雙手守護著代表
真心的小苗子，也守護著它成長的土地。我們的未來
有大佛加持就能共生共榮。

Planted trees under the Buddha's seat in the Buddha Museum.
People used their hands to guard the young seedling and the
land where it grows. Our future will coexist with the shared
glory from the blessing of the Buddha.

壓克力彩
Acrylic Color

24 × 33cm

151

佛館之心
Heart of Buddha Museum

能超法師｜臺灣／NENG CHAO｜Taiwan

● 2021 繪畫類 優選獎
 Painting Merit Award

代針筆 · 鉛筆 · 奇異筆
Technical Pen · Pencil · Sharpie Marker

21× 29.7cm

簡　歷｜Profile

現就讀於佛光山叢林學院女眾學部－經論教理系。

Currently studying at FGS Tsung Lin University Women's Buddhist College, Department of Sutras and Doctrine.

創作理念｜Concept

佛陀紀念館供奉著佛牙舍利，如佛陀在世，以各種方便權巧皆因有緣眾生，佛陀在菩提樹下，夜睹明星，大徹大悟，人人心中皆有一顆摩尼寶珠。

The Buddha Museum enshrines the Buddha's tooth relic. As if still alive, the buddha used skillful means to create affinities with the public. He sat underneath the bodhi tree and attained enlightenment. All sentient beings have Tathagata's wisdom.

防疫新生活
The New Life of Epidemic Prevention

妙念法師｜臺灣 ／ MIAO NIAN｜Taiwan

● 2021 繪畫類 優選獎
 Painting Merit Award

簡　歷｜Profile

現任澎湖佛光山信願寺監寺。曾服務於大明寺等別分院道場。

Currently serving as Superintendent of FGS Sin Yuan Temple in Penghu. She has previously served at Da Ming Temple and FGS branch temples in Taiwan.

創作理念｜Concept

防疫新生活。

The new life of epidemic prevention.

電腦繪圖
Computer Graphic

81x 85cm

小樹苗的故事
The Story of Sapling

慧人法師｜馬來西亞 ╱ HUI REN｜Malaysia

● **2021 繪畫類 優選獎**
 Painting Merit Award

簡　歷 ｜ Profile

曾服務於總本山都監院文書室三單書記、都監院行政組、
寺務監院室電訊組組長等。

Previously served as Deputy Head Secretary and Administration Unit
at Domestic & Overseas Executive Council, and Monastery Affairs
Department.

創作理念 ｜ Concept

此為普門雜誌「宗長開示」專欄的作品。以每期保和尚文
章主題為創作理念。

The work is published in the column of *Pumen Magazine*. The creative
concept coincides with Head Abbot, Hsin Bao's articles.

電腦繪圖
Computer Graphic

60x 60cm

幸福小屋
Sweet Cabin

有欣法師│臺灣 ／ YOU XIN │ Taiwan

● 2021 繪畫類 優選獎
　 Painting Merit Award

簡　歷 │ Profile

現任佛光山文教基金會。曾服務於總本山寶藏館展覽組、佛光緣美術館總部、佛陀紀念館佛光一滴等。

Currently serving at FGS Foundation for Buddhist Culture and Education. She has previously served at the Buddhist Museum, Fo Guang Yuan Art Gallery, Buddha Museum, etc.

創作理念 │ Concept

希望藉由樹屋與小熊家庭題材，呈現歡樂祥和溫馨的感覺。

Presenting a happy, peaceful and warm feeling through the theme of a tree house and bear family.

電腦繪圖
Computer Graphic

40x 40cm

菡萏鳥雀圖

Lotus and Bird

妙敬法師 | 臺灣 ╱ MIAO CHING | Taiwan

● 2021 繪畫類 優選獎
　　Painting Merit Award

簡　歷 | Profile

現任總本山修持監院室淨業林。曾服務於佛光山小港
講堂、鳳山講堂、潮州講堂等分別院道場弘法。

Currently serving at Amitabha Chanting Hall. She has preached
at Xiaogang, Fengshan, Chaozhou Lecture Hall, etc.

創作理念 | Concept

支持常住藝術弘法。

Supporting the temple to propagate the Dharma through art.

紙本設色
Ink and Color on Paper

66.3× 43.7cm

立體類

Three-dimension

三世苦

Sufferings of Three Lives

妙仲法師 | 臺灣 ╱ MIAO ZHUENG | Taiwan

● 2017 陶藝、工藝、書法類 佛光獎
 Ceramics, Artifacts and Calligraphy Fo Guang Award

簡　歷 | Profile

現任佛光緣美術館台北館主任，曾受派於高雄館、屏東館
等。擅長策展，以文化藝術弘法。

Currently serving as the Deputy Executive of Taipei Fo Guang Yuan Art
Gallery. She was previously dispatched to Kaohsiung and Pingtung Fo
Guang Yuan Art Gallery. She is good at curation and propagating the
Dharma through culture and arts.

創作理念 | Concept

忘了，受了多少苦，藏了多少恨；其尖似螺釘，一動即痛。
何時，看透因緣，觀照自心；刺心之釘， 一一釋出。

Forgetting all the suffering and hidden hates. Piercing like the tip of a
screw, it hurts when it moves. When one truly accepts the concept of
cause and conditions and reflects oneself, those heart-piercing pains
can be released one by one.

陶土
Pottery Clay

23.5x23.5cm

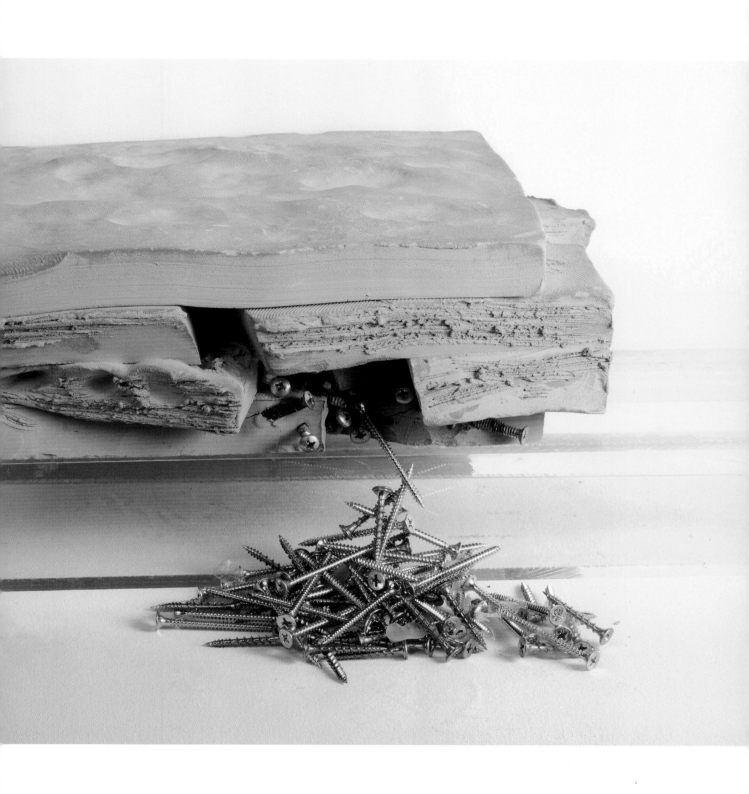

千瘡百孔

Countless Pores

妙仲法師 | 臺灣 ／ MIAO ZHUENG | Taiwan

● 2017 陶藝、工藝、書法類 佛光獎
 Ceramics, Artifacts and Calligraphy Fo Guang Award

創作理念 | Concept

很多苦，苦不堪言；
一而再，再而三，
螺釘鑽進又鑽出。
一次次，千瘡百孔。

There are so much sufferings and miseries; happening over and over again; like screws drilling in and out. Time after time, it becomes a gaping wound.

陶土
Pottery Clay

23.5x23.5cm

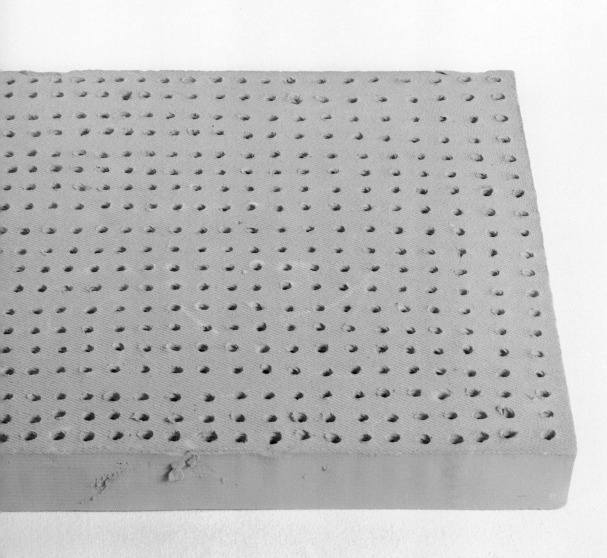

千層浪

Thousand Layered Waves

妙仲法師 | 臺灣 ╱ MIAO ZHUENG | Taiwan

● 2017 陶藝、工藝、書法類 佛光獎
 Ceramics, Artifacts and Calligraphy Fo Guang Award

創作理念 | Concept

來時路，純淨雪白。
一番作為，像極英雄，
卻也泥濘不堪。

On the way, the road was pure and white as snow. After some work, while like a hero, the journey ahead remains rough and not any easier.

陶土
Pottery Clay

23.5x23.5cm

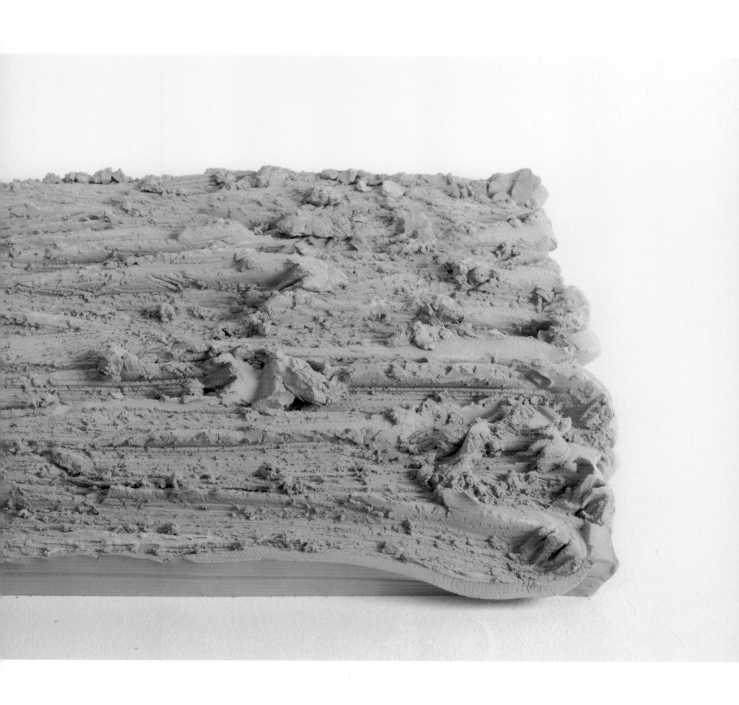

默（一組 14 件）
Silence (A Set of 14)

知修法師｜馬來西亞 ╱ ZHI XIU｜Malaysia

● 2018 立體類 佛光獎
 Three-dimension Fo Guang Award

簡　歷 | Profile

現於佛光山福國寺。曾服務於三重禪淨中心、佛陀紀念館
等。

Currently serving at Fu Guo Temple. She has also served at Sanchong
Meditation Center and Buddha Museum.

創作理念 | Concept

一默一聲雷，無聲勝有聲。

Although silent but more like a thunder. Silence is always better than
words.

輕黏土
Light Clay

6x6x9.5cm~2x2x4cm

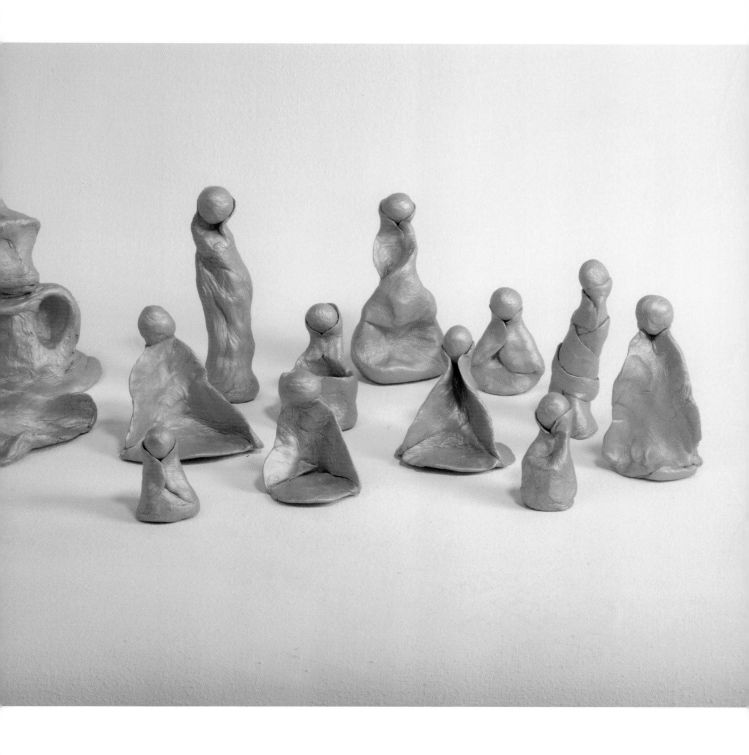

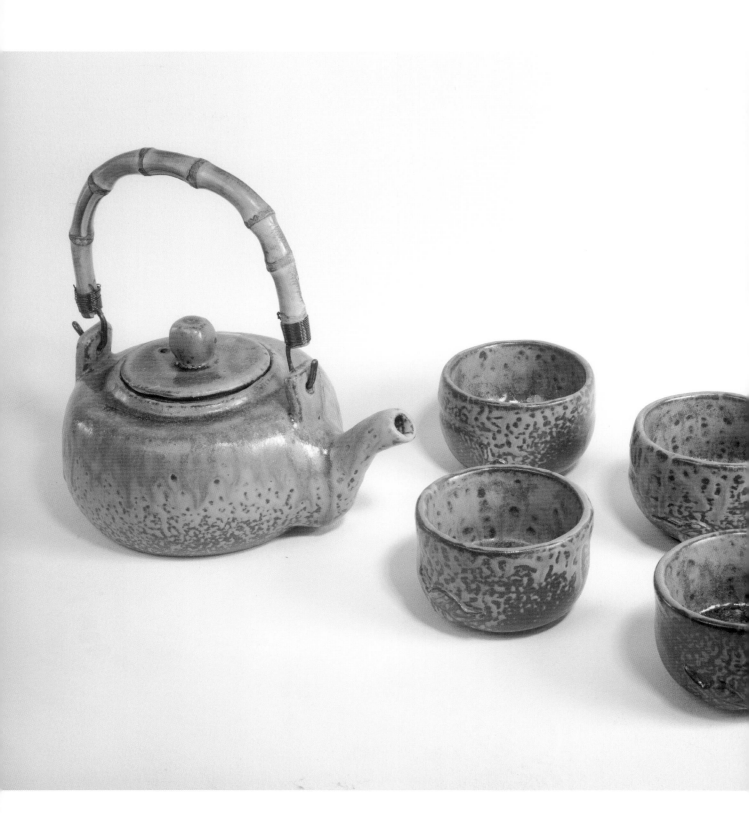

提壺杯組
Teapot Set

覺霖法師 ｜ 臺灣 ╱ JUE LIN ｜ Taiwan

● 2019 立體類 佛光獎
Three-dimension Fo Guang Award

簡　歷 ｜ Profile

現任佛光山佛陀紀念館法務處執行長。曾任泰山禪淨中心
與屏東講堂監寺。

Current Chief Executive at the Buddha Museum. She has previously
served at the Taishan Meditation Center and Pingtung Lecture Hall.

創作理念 ｜ Concept

藉陶觀心，觀陶性與人性。從心出發，陶之用，於生活中。

Contemplating the mind through pottery, while observing pottery and
humanity. Arising from the mind, the usage of pottery is part of our
life.

陶土
Pottery Clay

壺 -18×13×10cm
杯 -7×7×6cm

彌陀遍十方

Amitabha Pervading in All Directions

有紀法師｜新加坡／YOU JI｜Singapore

● 2020 立體類 佛光獎
　　Three-dimension Fo Guang Award

簡　歷｜Profile

現於澳洲佛光山南天寺。曾服務於澳洲佛光山西澳道場、
《世界佛教美術圖說大辭典》英文編輯組。擅長佛教美術
創作。

Currently serving at Nan Tien Temple. She has also served at the IBAA
Western Australia and the *Encyclopedia of World Buddhist Arts*. She is
skilled at Buddhism art creations.

創作理念｜Concept

來自一位人間佛教行者的祝福。

A blessing from a practitioner of Humanistic Buddhism.

PLA 3D 列印
PLA 3D Print

18.5x 18.5x 18.5cm

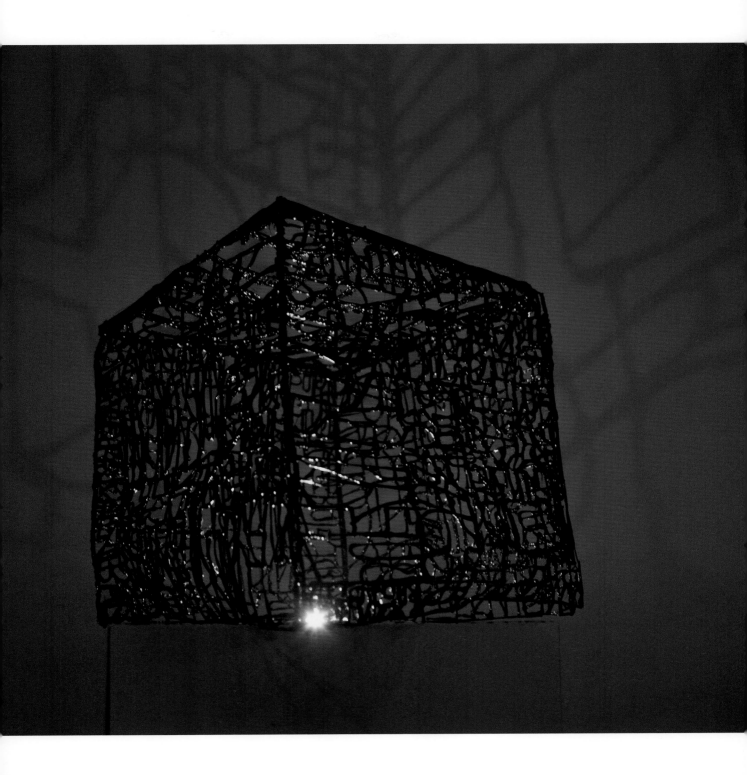

夢幻泡影 -《金剛經》

The Diamond Sutra - Dream, Illusion, Bubble and Shadow

南天寺 | 澳洲 ╱ FO GUANG SHAN NAN TIEN TEMPLE | Australia

● 2021 立體類 佛光獎
 Three-dimension Fo Guang Award

簡　歷 | Profile

澳洲佛光山南天寺是南半球最大的佛寺，南天寺由住持滿
可法師秉持星雲大師「以文化弘揚佛法，以教育培養人才，
以慈善福利社會，已成為當地最具特色的宗教巡禮聖地，
並不斷向落實佛教本土化的方向邁進。

Fo Guang Shan Nan Tien Temple is the largest Buddhist temple in the
southern hemisphere. The Abbot of the temple is Venerable Man Ko.
Under the guidance of Venerable Master Hsing Yun's four objectives
for the temple, it has become the most distinctive religious pilgrimage
site in the area, while continue to localize Buddhism in its communities.

創作理念 | Concept

此作品是一部圓形透明及半透明塑膠片一字一圈組成的《金
剛經》。透明及半透明塑膠片若隱若現，呈現夢幻泡影的
效果。

The *Diamond Sutra* is composed of circular transparent and translucent
plastic sheets, appearing indistinctly while presenting a dreamy bubble
effect.

複合媒材
Mixed Media

600x 200cm

新生

New Born

妙熙法師｜臺灣 ／ MIAO XI｜Taiwan

● 2018 立體類 菩提獎
　　Three-dimension Bodhi Award

簡　歷｜Profile

現任人間福報社社長。曾任人間福報社總編輯、開山寮法
堂書記一室副總編輯。出版有《走進阿蘭若》、《行腳印
度》、《人間菩提味》等書。

Currently serving as Publisher of *The Merit Times*. She has previously
served at *The Merit Times* and the Office of the Founding Master. She
has also published several books: *Entering Aranya*, *Traveling India*,
Bodhi around the World, among others.

創作理念｜Concept

葉落盡時萬物蕭然，生命此刻卻正萌芽。人之困頓亦然，
切莫執於世間表象。

When all the leaves have fallen, all things become desolated. New life
actually starts to sprout at that moment. The same goes to humans
in extenuating circumstances, one must not become attached to the
world's appearance.

複合媒材
Mixed Media

102x 24.5x 3.5cm

華嚴三聖

The Western Three Saints

滿聰法師｜馬來西亞 ╱ MAN TSUNG｜Malaysia

● 2019 立體類 菩提獎
　Three-dimension Bodhi Award

簡　歷｜Profile

現服務於馬來西亞佛光山新馬寺。長期派駐海外道場弘法，
足跡遍及澳洲、加拿大、美國關島等。

Currently serving as staff at the Hsingma Si, Malaysia. She was
previously stationed at various FGS overseas branch temples, including
Australia, Canada and Guam.

創作理念｜Concept

運用「十字繡」的概念創作鑽石畫。人造水晶和圖案，以
專注、時間與耐心，成就一幅精美的畫作。

Using the technique of "cross stitching", a diamond painting was
created. With focus, time and patience, a beautiful painting was
produced with artificial crystals and patterns.

複合媒材
Mixed Media

151× 100cm

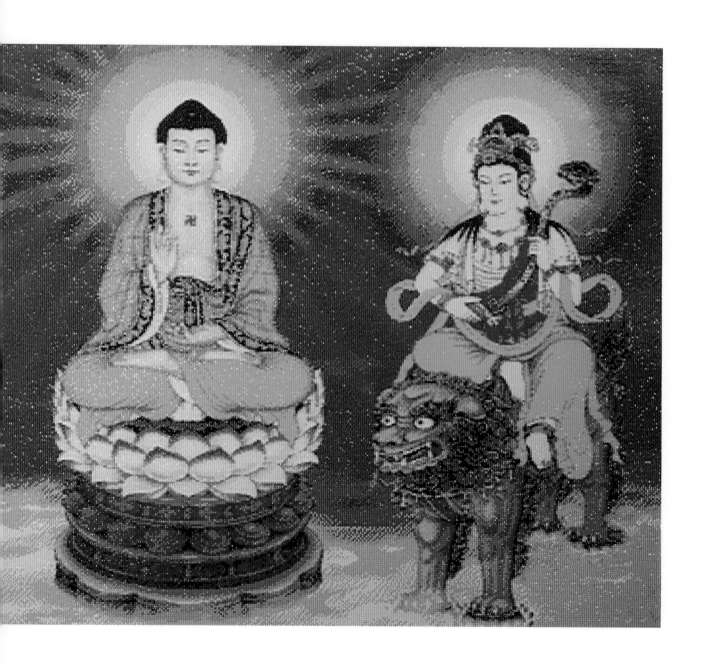

福祿 · 蓮花

Blessings - Lotus

知田法師 | 馬來西亞 / ZHI TIEN | Malaysia

● 2020 立體類 菩提獎
 Three-dimension Bodhi Award

簡　歷 | Profile

現於佛光山永和學舍。曾服務於鳳山講堂。

Currently serving at Younhe Temple. She has also served at Fongshan
Lecture Hall.

創作理念 | Concept

跳脫葫蘆的原來面目，裁剪、切割，成為象徵佛教的蓮花。

Using cutting techniques on the surface of the gourd, it became a
lotus flower that symbolizes Buddhism.

葫蘆
Gourd

32x 18.8x 23cm

師父上人

Venerable Master

妙松法師 | 臺灣 ╱ MIAO SONG | Taiwan

● 2021 立體類 菩提獎
Three-dimension Bodhi Award

簡　歷 | Profile

現於國際佛光會中華總會，曾服務於佛光山金光明寺、文化院、開山寮法堂書記室等。

Currently serving at the BLIA. She has also served at Jin Guang Ming Temple, the Culture Council, the Office of Founding Master, etc.

創作理念 | Concept

一顆種子，一份祝福。

A seed, a blessing.

種子
Seed

30x 47x 0.2cm

根源（茶器組）

Origin

有法法師｜馬來西亞 ／ YOU FA｜Malaysia

- 2018 立體類 般若獎
 Three-dimension Prajna Award

簡 歷｜Profile

現任佛光緣美術館澳洲南天館主任。曾任佛光山惠中寺監院、佛光緣美術館總部及台北、台中館主任。擅長策展與美術設計。

Currently serving as Chief Executive of Fo Guang Yuan Nan Tien Art Gallery in Australia. She has served at Hui Chung Temple, Fo Guang Yuan Main Art Gallery, Taipei and Taichung Fo Guang Yuan Art Gallery.

創作理念｜Concept

自然陶藝，隨緣創作。想像力與忍耐力，當下即是。

Natural pottery is created freely. Imagination and endurance are in the present moment.

陶土
Pottery Clay

12x 18x 12cm
6.5x 6cm

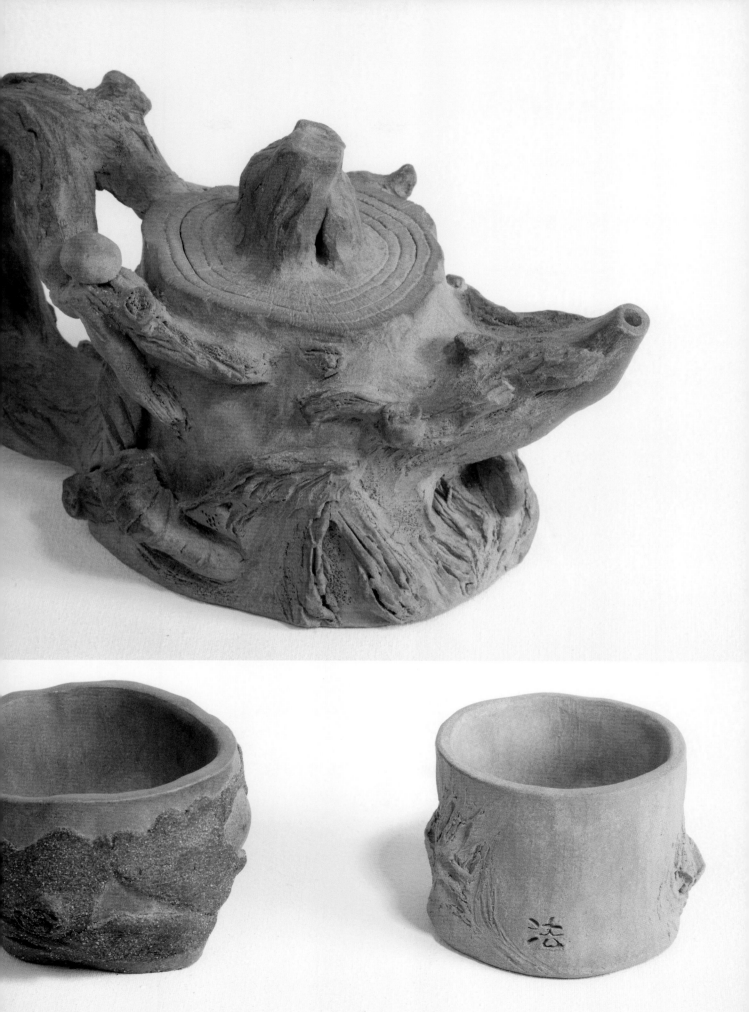

茶倉罐
Tea Container

覺霖法師 ┃ 臺灣 ╱ JUE LIN ┃ Taiwan

● 2020 立體類 般若獎
　　Three-dimension Prajna Award

簡　歷 ┃ Profile

現任佛光山佛陀紀念館法務處執行長。曾任泰山禪淨中心
與屏東講堂監寺。

Current Chief Executive at the Buddha Museum. She has previously
served at the Taishan Meditation Center and Pingtung Lecture Hall.

創作理念 ┃ Concept

藉陶觀心，觀陶性與人性。從心出發，陶之用，於生活中。

Contemplating the mind through pottery, while observing pottery and
humanity. Arising from the mind, the usage of pottery is part of our
life.

陶土
Pottery Clay

14x 13cm

心經

Heart Sutra

妙耀法師 | 臺灣 ╱ MIAO YAO | Taiwan

● 2021 立體類 般若獎
 Three-dimension Prajna Award

簡　歷 | Profile

現服務於大阪佛光山寺。十多年來於日本分別院道場弘法。

Currently serving at the Osaka FGS Temple. She has preached Dharma at the Japan FGS branch temple for over a decade.

創作理念 | Concept

利用自然的蘭花葉編織，以篆體字於葉面上書寫心經。祈願疫情早日消除，國泰民安。

Using natural orchid leaves to weave. The *Heart Sutra* is written on the leaves in a seal script. May the epidemic be eliminated soon, the country prospers, and the people at peace.

複合媒材
Mixed Media

30x 20cm

壺承、盤、梅花盤

Teapot Pad
Plate
Plum Shaped Plate

依潤法師｜臺灣 ／ YI RUN｜Taiwan

● 2019 立體類 優選獎
　 Three-dimension Merit Award

簡　歷｜Profile

現任佛光山佛陀紀念館副館長。曾任總本山寺務監院室監
院及台北道場等。擅長法務、法器教學等。

Current Vice-Deputy Curator of Buddha Museum. Skilled at Dharma
affairs and Dharma instrument teaching, she has served at Monastery
Affairs Department and the Taipei Vihara.

創作理念 │ Concept

透過捏陶調伏身心，使心更細膩柔軟；如同捏塑過程，感
覺到柔軟的陶土也在呼吸。

Through molding the pottery, the body and mind is subdued. The
heart also becomes more exquisite and soft. It is similar the feeling of
soft clay as it breathes through the the process of molding.

陶土
Pottery Clay

16.5×16.5×4.5cm
13.5×13.5×2.5cm
17×17×3cm

白度母菩薩
White Tara

滿化法師｜台灣 ／ MAN HUA｜Taiwan

● 2019 立體類 優選獎
　 Three-dimension Merit Award

簡　歷 ｜ Profile

現任佛光山松山寺監寺。曾服務於寶塔寺等道場，並
曾派駐首爾佛光山寺。

Currently serving as the Superintendent of Songshan Temple.
She previously served at Bao Ta Temple and was stationed at
Seoul FGS Temple.

創作理念 ｜ Concept

藉由創作認識花草、資源再利用，並培養專注與觀察
力。

Through creative work, I have learned about flowers, plants and
recycling, while cultivating my concentration and observation.

押花
Pressed Flower Craft

40x60cm

和諧
Harmony

滿化法師｜臺灣 ／ MAN HUA｜Taiwan

● 2020 立體類 優選獎
Three-dimension Merit Award

創作理念｜Concept

多元材料培養惜福愛物；訓練專注力、修身養性，分享押花的喜悅。

Cherishing one's blessings and possessions through multi-elements, training one's concentration, self-cultivation, and sharing the joy of pressed flowers.

押花
Pressed Flower Craft

40x40cm

一心三觀

Three Insights in One Thought

覺尚法師 ｜ 臺灣 ／ JUE SHANG ｜ Taiwan

● 2019 立體類 優選獎
 Three-dimension Merit Award

複合媒材
Mixed Media

120×92×90cm

簡　歷 ｜ Profile

現任佛光山極樂寺監寺。長期派駐於臺灣各別分院道場弘法。

Current Superintendent of Chi Le Temple. She has been stationed at various FGS branch temples throughout Taiwan.

創作理念 ｜ Concept

一顆顆的圓象徵人的內心世界，朝夕共處，同吃一鍋飯，卻總有不同的人生觀；好比天台宗一心三諦的觀法，似假、似空的人生如何自在呢？大概就從觀空、觀假中，開發中道的智慧吧。

The circle symbolizes one's inner world, like the "Three Axioms in One Thought" of the Tiantai school. How can a life that seems to be false and empty carry on? Acquire the wisdom of the middle way through the contemplation of emptiness and falseness.

禾香花瓶
Fragrance of Rice Field Vase

覺鴻法師 | 臺灣 ／ JUE HUNG | Taiwan

● 2020 立體類 優選獎
 Three-dimension Merit Award

簡 歷 | Profile

現任佛光山南台別院監院。曾服務於國際佛光會中華總會，及派駐臺灣與香港道場弘法。

Current Superintendent of Nan Tai Temple. She has previously served at the BLIA Chunghwa Headquarters and has been stationed at Taiwan and Hong Kong.

創作理念 | Concept

捏塑之始心與土是兩物，以耐心慢慢揉捻，融合為一。插花擺飾皆宜！

The initial concept of kneading and clay are two different things. They were slowly blended with patience to coexist in harmony. It is suitable for display of flower arrangements and decorations!

陶土
Pottery Clay

12x12cm

長衫布背包
出差用布背包
側肩小背包

Robe Backpack
Business Travel Backpack
Crossbody Shoulder Bag

覺性法師 | 臺灣 ／ JUE HSING | Taiwan

● 2019 立體類 優選獎
　　Three-dimension Merit Award

簡　歷 | Profile

現服務於佛光大學工程組。曾服務於總本山及派駐臺灣與
中國大陸道場弘法。

Currently serving at Fo Guang University. She has previously served
at the FGS main temple and has been stationed to other FGS branch
temples in Taiwan and Mainland China.

創作理念 | Concept

故障的雨傘布及破舊黃長衫，以環保的心成就實用的布背
包。

With conserving the environment in mind, the use of faulty umbrella
fabric and dilapidated yellow gown make practical cloth backpacks.

布
Cloth

29×10×38cm
30×12×36cm
23×6×25cm

環保與心保
Environmental and Spiritual Preservation

覺瑋法師｜新加坡／JUE WEI｜Singapore

● 2020 立體類 優選獎
Three-dimension Merit Award

簡　歷｜Profile

現任澳洲南天大學人間佛教中心主任。曾服務於美國
西來大學，專長研究與講學。

Current Deputy Executive at Nan Tien University. Skillful at
research and lecture, she has previously served at Hsi Lai
University.

創作理念｜Concept

2020 年澳洲森林大火暨全球疫情，想起師父上人提
倡的環保與心保。綠色大地與藍色天空，以心祝願世
界康泰。

In 2020, Australia's forest fires and the pandemic have
reminded me of Master's advocacy for the environmental and
spiritual preservation of a green earth and blue sky. Wish the
world be healthy and strong.

壓克力彩
Acrylic Color

30x30x1.5cm
20x20x1.5cm

星動
Star Motion

妙熙法師 | 臺灣 ╱ MIAO XI | Taiwan

● 2019 立體類 優選獎
　Three-dimension Merit Award

簡　歷 | Profile

現任人間福報社社長。曾任人間福報社總編輯、開山寮
法堂書記一室副總編輯。出版有《走進阿蘭若》、《行
腳印度》、《人間菩提味》等書。

Currently serving as Publisher of *The Merit Times*. She has
previously served at *The Merit Times* and the Office of the
Founding Master. She has also published several books: *Entering
Aranya*, *Traveling India*, *Bodhi around the World*, among others.

創作理念 | Concept

祥和之夜，貓頭鷹一家享受夜的寧靜，月光灑落，星
光流動。

The owl family enjoys the tranquility of a peaceful night. The
moonlight is falling and stars are flowing.

天然礦石
Natural Ore

50x70cm

孔雀明王菩薩（Q 版）
Mahamayuri "Chibi"

妙具法師｜臺灣 ／ MIAO JU｜Taiwan

● 2019 立體類 優選獎
　Three-dimension Merit Award

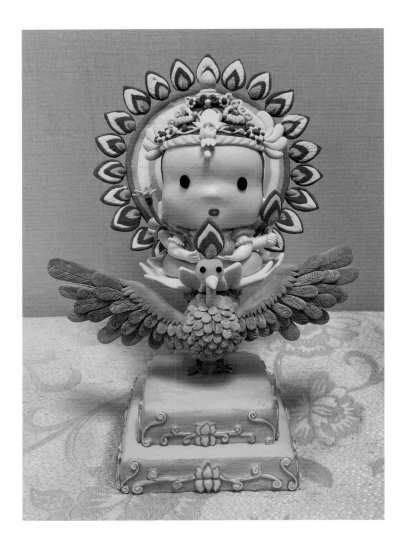

簡　歷｜Profile

現任佛光山永和學舍監寺。曾服務於人間福報社、國際
佛光會中華總會及臺灣別分院道場。

Current Superintendent of Younhe Temple. She has previously
served at *The Merit Times*, BLIA Chunghua Headquarters and FGS
branch temples in Taiwan.

創作理念｜Concept

Q 版造型孔雀明王，希令人心生歡喜，更願以此令一切
有情滅除災惱、獲得安樂。

The Q (cute) version of the Mahamayuri, in hopes of giving people
joy from the heart. Also wish it could alleviate all sentient beings
from sufferings and defilements, instead receive stability and
happiness.

複合媒材
Mixed Media

26×24×35cm

198

佛在心中行六度

With Buddha in Mind, Cultivate Six Perfections

如昭法師 | 臺灣 ／ RU ZHAO | Taiwan

● 2019 立體類 優選獎
　Three-dimension Merit Award

簡　歷 | Profile

現任佛光山佛陀紀念館總務組暨禮敬大廳知客室二、三樓主任。
曾服務於惠中寺等臺灣別分院道場。

Currently serving as Chief Executive at Buddha Museum. She has also served
at the Hui Chung Temple and other FGS branch temples in Taiwan.

創作理念 | Concept

推動師父上人以文化弘揚佛法之目的，供養大眾。

An offering to the public by promoting Master's concept is propagating the
Dharma through culture.

複合媒材
Mixed Media

110×78×8cm

師父上人

Venerable Master

妙松法師｜臺灣／ MIAO SONG ｜ Taiwan

● 2020 立體類 優選獎
　Three-dimension Merit Award

簡　歷 ｜ Profile

現於國際佛光會中華總會，曾服務於佛光山金光明寺、文化院、開山寮法堂書記室等。

Currently serving at the BLIA. She has also served at Jin Guang Ming Temple, the Culture Council, the Office of Founding Master, etc.

創作理念 ｜ Concept

本栖湖畔水天一色。師父上人凝視遠方，衣角飄飄，映現雲水三千弘化之心。

The waters and skies merge in one color beside Lake Motosu. The Master stared into the distance, his clothes fluttered in the air, reflecting on the cloud and water with a propagating mind.

輕黏土、壓克力彩
Light Clay - Acrylic Color

41x31.5cm

聆聽

Listening Respectfully

妙昱法師 | 臺灣 / MIAO YU | Taiwan

● 2019 立體類 優選獎
 Three-dimension Merit Award

押花
Pressed Flower Craft

48×40cm

簡　歷 | Profile

現任佛光山陀紀念館財務室福田主任及人間文教基金會服務。曾派駐臺灣別分院道場弘法。

Currently serving as Deputy Executive at the Buddha Museum, and FGS Foundation for Buddhist Culture and Education. She has been dispatched to various FGS branch temples in Taiwan.

創作理念 | Concept

星雲大師《無聲息的歌唱》，是一默一雷的震撼，劃破古今，您聽到否？

Venerable Master Hsing Yun's book *Bells, Gongs, and Wooden Fish* expounds the shocking effect between a moment of silence and the sound of thunder. Resonating from the past to the present, have you heard it?

點燈的人
A Person Who Lit a Lamp

知安法師｜台灣 ╱ ZHI AN｜Taiwan

● 2020 立體類 優選獎
　 Three-dimension Merit Award

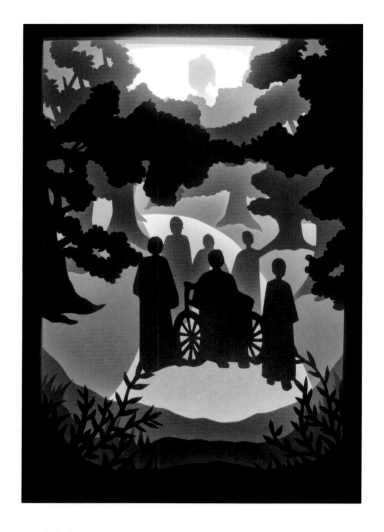

簡　歷｜Profile

現於佛光山泰山禪淨中心。曾服務於佛光緣美術館屏東館。

Currently serving at Taishan Meditation Center. She has also served at Pingtung Fo Guang Yuan Art Gallery.

創作理念｜Concept

以慧延法師攝影作品構圖，畫面溫暖動人。「點燈的人」，供養佛陀、師父上人及大眾。

The composition of this artwork is based on the photographs of Venerable Hui Yin, which was a warm and touching image. "A Person Who Lit a Lamp" makes an offering to the Buddha, Master and the public.

剪紙、燈
Paper Cutting - Lamp

7x17x26cm

悟與迷（二件組）
Enlightenment and Ignorance

知修法師｜馬來西亞／ZHI XIU｜Malaysia

● 2020 立體類 優選獎
 Three-dimension Merit Award

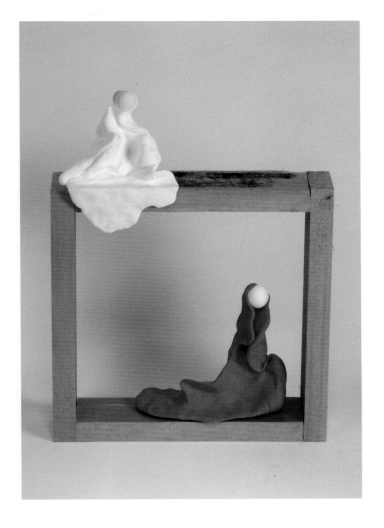

簡　歷｜Profile

現於佛光山福國寺。曾服務於三重禪淨中心、佛陀紀念館等。

Currently serving at Fu Gou Temple. She has also served at Sanchong Meditation Center and Buddha Museum.

創作理念｜Concept

喜歡禪意，透過作品展現自由無限與自然無聲的發展，成其本來面目。

I like Chan. To showcase the unlimited freedom and silent development of nature through this work, the original look was revealed.

輕黏土
Light Clay

9x5x13cm

葫蘆娃娃
Bottle Gourd Doll

知田法師｜馬來西亞 ／ ㄓ

● 2019 立體類 優選獎
Three-dimension M

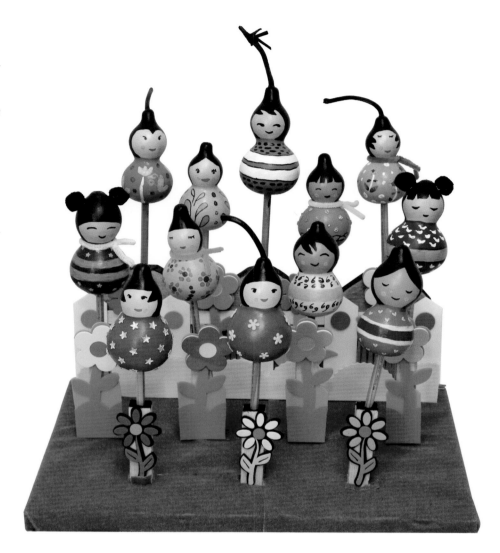

簡　歷 | Profile

現於佛光山永和學舍。曾服務於鳳山講堂。

Currently serving at Younhe Temple. She has also served at Fongshan Lecture Hall.

創作理念 | Concept

藉人間大學的葫蘆雕刻班學習，發願參加聯展，以激勵自己要不斷進步。

Through the gourd carving class offered at Fo Guang Shan Open University, my participation in this exhibition is a way to improve myself constantly.

葫蘆彩繪
Painted Gourd

40×30×45cm

不忘初心

Never Forget One's Initial Aspirations

戴淑芬師姑｜香港 ／ DAI SHU FEN｜Hong Kong

● 2019 立體類 優選獎
 Three-dimension Merit Award

簡　歷｜Profile

長期服務於佛光山電子大藏經。

Long service at the Buddhist Canon Research Department.

創作理念｜Concept

以星雲大師往事百語中「不忘初心」
為座右銘，故以十字繡臨摹。

Based on "Never Forget One's Initial Aspirations" of Venerable Master Hsing Yun's *Hundred Saying Series*, I have present it with cross stitch.

複合媒材
Mixed Media

16.5x27.6cm

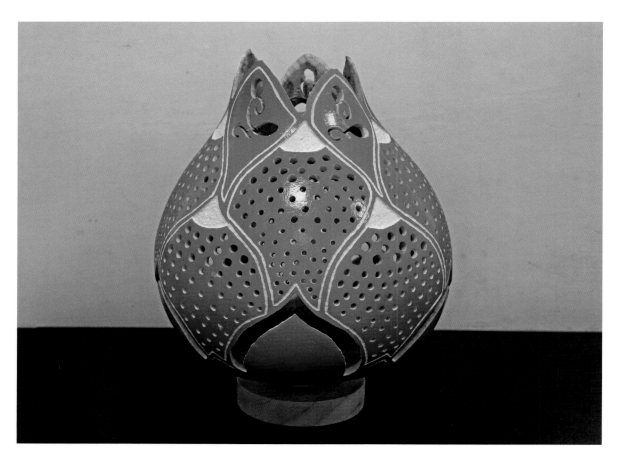

蓮花遍地生

Lotus Grow Everywhere

知田法師 ｜ 馬來西亞 ／ ZHI TIEN ｜ Malaysia

● 2021 立體類 優選獎
　Three-dimension Merit Award

簡　歷 ｜ Profile

現於佛光山永和學舍。曾服務於鳳山講堂。

Currently serving at Younhe Temple. She has also served at Fongshan Lecture Hall.

創作理念 ｜ Concept

藉由葫蘆創作，發揮佛教概念。

Developing the Buddhist concept through the creative work of gourd.

葫蘆
Gourd

20x 20x 30cm

攝影類
Photography

寒山僧蹤

The Monk's Trace at Hanshan

慧融法師 | 臺灣 ╱ HUI RONG | Taiwan

● 2017 攝影類 佛光獎
 Photography Fo Guang Award

簡　歷 | Profile

現任總本山寺務監院室監院。熟稔法務梵唄唱誦。曾任佛
光山叢林學院男眾學部總務長等職。

Current Department Head of Monastery Affairs Department. He is
familiar with Dharma services and hymn. He has previously served at
FGS Tsung Lin University.

創作理念 | Concept

林中迷霧，人間苦迷。佛子獨行，林中悟自性，人間度群迷。

The fogged forest like the human world is full of suffering and
ignorance. A Buddhist walks alone in the forest to be enlightened of
one's self-nature, and to liberate all the sentient beings.

豐收之喜

Joy of Harvest

黃進寶教士｜馬來西亞 ╱ NG CHIN POH｜Malaysia

● 2018 攝影類 佛光獎
　 Photography Fo Guang Award

簡　歷｜Profile

現於印度佛光山德里文教中心、印度德里沙彌學園。曾派
駐馬來西亞、多倫多、臺灣等別分院道場。

Currently serving at New Delhi Educational & Cultural Centre, Delhi
Sramanera College, India. He was previously stationed at FGS branch
temples in Malaysia, Toronto and Taiwan.

創作理念｜Concept

走過聖地，留下回憶。

When passing through the holy land, the memories that were left behind.

（局部）

我是佛

I am Buddha

妙勇法師｜馬來西亞 ╱ MIAO YONG｜Malaysia

● 2019 攝影類 佛光獎
　　Photography Fo Guang Award

簡　歷｜Profile

現於馬來西亞佛光山新馬寺，曾服務於馬來西亞佛光山東禪寺、澳洲南天寺、佛光山文教基金會等。

Currently serving at the Hsing Ma Shi in Malaysia. She has previously served at FGS Dong Zen Temple, Nan Tien Temple and the FGS Foundation for Buddhist Culture & Education.

創作理念｜Concept

用眼睛與內心的世界去感受美好的大自然、大宇宙。萬物生靈，自有生命。

To Feel nature's beauty with eyes and minds, all creatures in the universe have their own spirits and lives.

束縛 v 解脫

Confinement Versus Liberation

覺如法師｜馬來西亞 ／ MIAO YONG｜Malaysia

● 2021 攝影類 佛光獎
　Photography Fo Guang Award

簡　歷｜Profile

現任於澳洲佛光山尔有寺監寺。曾任於瑞士佛光山、歐洲
地區副總住持、倫敦佛光山住持等分別院道場弘法。

Current Superintendent at Fo Guang Shan Buddhist Temple Boxhill.
She has previously served and preached at Switzerland, London, and
FGS branch temples.

創作理念｜Concept

讓生命從一切束縛中解脫，獲得永恒的法樂。

To free one's life from all confinements and acquire the eternal joy of
Dharma.

師徒情

The Mentorship between Master and Disciples

如輝法師 | 臺灣 ╱ RU HUI | Taiwan

● 2017 攝影類 菩提獎
 Photography Bodhi Award

簡　歷 | Profile

現任佛光山文教基金會辦公室主任。曾任佛光山佛陀紀念館電子媒體組組長、臺中光明學苑主任，及於人間大學、金光明寺等地服務。

Currently serving at FGS Foundation for Buddhist Culture and Education. She has previously served at Buddha Museum, Guang Ming Learning Center, FGS Open University, and Jing Kuang Ming Temple, etc.

創作理念 | Concept

師徒之情無法言喻。師父歡喜就是徒眾最大的歡喜。

The guidance of mentorship received by disciples is indescribable by words. Master's joy is the greatest joy of the disciples.

悠悠自在漫步叢林

Walking Carefreely at the Monastery

妙勇法師｜馬來西亞 ╱ MIAO YONG｜Malaysia

● 2018 攝影類 菩提獎
 Photography Bodhi Award

簡　歷 | Profile

現於馬來西亞佛光山新馬寺，曾服務於馬來西亞佛光山東禪寺、澳洲南天寺、佛光山文教基金會等。

Currently serving at the Hsing Ma Shi in Malaysia. She has previously served at FGS Dong Zen Temple, Nan Tien Temple and the FGS Foundation for Buddhist Culture & Education.

創作理念 | Concept

以眼與心感受美好的大自然。宇宙萬物生靈，自有生命。

To feel nature's beauty with eyes and minds, all creatures in the universe have their own spirits and lives.

燈燈相照

Lamps Shine

妙端法師 ｜ 臺灣 ／ MIAO DUAN ｜ Taiwan

● 2019 攝影類 菩提獎
 Photography Bodhi Award

簡　歷 ｜ Profile

現任佛光大藏經編藏處，曾服務於女眾傳燈會等。

Currently serving as Editor of Buddhist Canon Research Department.
She has previously served on the Sangha Affairs Committee, etc.

創作理念 ｜ Concept

希望藉由攝影，將佛光山的美呈現於眾人面前，給人歡喜。

Hope to present the beauty of Fo Guang Shan through photography
and give joy to everyone.

感應道交

Interaction between Stimulus and Response

乘良沙彌 | 印度 ／ CHENG LIANG | India

● 2020 攝影類 菩提獎
 Photography Bodhi Award

簡　歷 | Profile

印度佛光山德里沙彌學園學生。

Student of Delhi Sramanera College, India.

創作理念 | Concept

「禮佛一拜罪滅河沙」，行者與菩薩的感應道交，就在這一刻的虔誠頂禮之中。

"Prostrate to the Buddha and eliminate the bad karma like sand in a river." The interaction between the practitioner and the Bodhisattva can be sensed in the pious prostration at this very moment.

明月清涼

Refreshing Moon

如輝法師 | 臺灣 ／ RU HUI | Taiwan

● 2021 攝影類 菩提獎
 Photography Bodhi Award

簡　歷 | Profile

現任佛光山文教基金會辦公室主任。曾任佛光山佛陀紀念館電子媒體組組長、臺中光明學苑主任，及於人間大學、金光明寺等地服務。

Currently serving at FGS Foundation for Buddhist Culture and Education. She has previously served at Buddha Museum, Guang Ming Learning Center, FGS Open University, and Jing Kuang Ming Temple, etc.

創作理念 | Concept

夜中有我，我心如佛。
佛心如月，月照大千。

I am in the dark and my mind is like a Buddha.
Buddha's mind is as bright as the moon and it shines on the universe.

白塔倒影

Inverted Image of the White Pagoda

妙開法師 | 臺灣　╱　MIAO KAI | Taiwan

● 2017 攝影類 般若獎
　　Photography Prajna Award

簡　歷 | Profile

現任馬來西亞佛光出版社執行編輯。曾任人間福報代理社長、人間通訊社社長、人間福報總編輯等。

Currently serving as Executive Editor of Buddha's Light Publishing in Malaysia. She has also served at *The Merit Times* and Life News Agency.

創作理念 | Concept

雨後天清，地面一窪水倒映出佛光祖庭大覺寺白塔之美。

The sky was clear after the rain, and a puddle of water on the ground reflected the beauty of the white pagoda at the Dajue Temple of Fo Guang ancestral temple.

點亮心燈

Light the Lamp of Heart

乘銘沙彌 | 印度 ／ CHENG MING | India

● 2018 攝影類 般若獎
Photography Prajna Award

簡 歷 | Profile

印度佛光山德里沙彌學園學生。

Student of Delhi Sramanera College, India.

創作理念 | Concept

漫長黑夜與無明人生，燈可照亮；寒冷冬天與冷漠人心，
燈可溫暖。奉獻了自己，照亮了別人。

Long nights, living an ignorant life can be illuminated by lights. Cold winters and unsympathetic hearts can be warmed by lights. By giving yourself, you can light up others.

淨土之美
Beauty of Pure Land

有寧法師 | 臺灣 ／ YOU NING | Taiwan

● 2019 攝影類 般若獎
 Photography Prajna Award

簡　歷 | Profile

現於總本山寺務監院室環保組。曾服務於佛光緣美術館總部、佛光山台南講堂、佛陀紀念館知客室等。

Currently serving at Monastery Affairs Department. She has also served at Fo Guang Yuan Art Gallery Headquarters, Tainan Lecture Hall, and Buddha Museum.

創作理念 | Concept

展現佛光淨土之美。

To display the beauty of Buddha light's pure land.

粥。恩來

Porridge, Kindness has Arrived

慧中法師│臺灣 ╱ HUI ZHONG│Taiwan

● 2020 攝影類 般若獎
Photography Prajna Award

簡　歷│Profile

現任佛光山叢林學院男眾學部教務長。曾於中國大陸北京光中文教館等單位弘法。擅長教學，曾任叢林學院男眾學部教務長。

Current Department Head of Academic Affairs of FGS Tsung Lin University. Skillful at teaching, he has served at the Guangzhong Culture and Education Center in Beijing, and FGS Tsung Lin University.

創作理念│Concept

寒冬臘月的清晨，走過師父上人修建前往江西宜豐黃檗村的路。在臨濟祖庭所在地民宅，燒柴煮臘八粥與村民結緣，為報祖師及家師之恩。

In the early morning of a severe winter, I passed by the road built by Master to go to Huangbo Village in Yifeng, Jiangxi. In the residence of Linji's ancestral temple, he burned firewood and cooked laba congee to create affinities with the villagers in tribute to the patriarchs and the Master teacher's kindness.

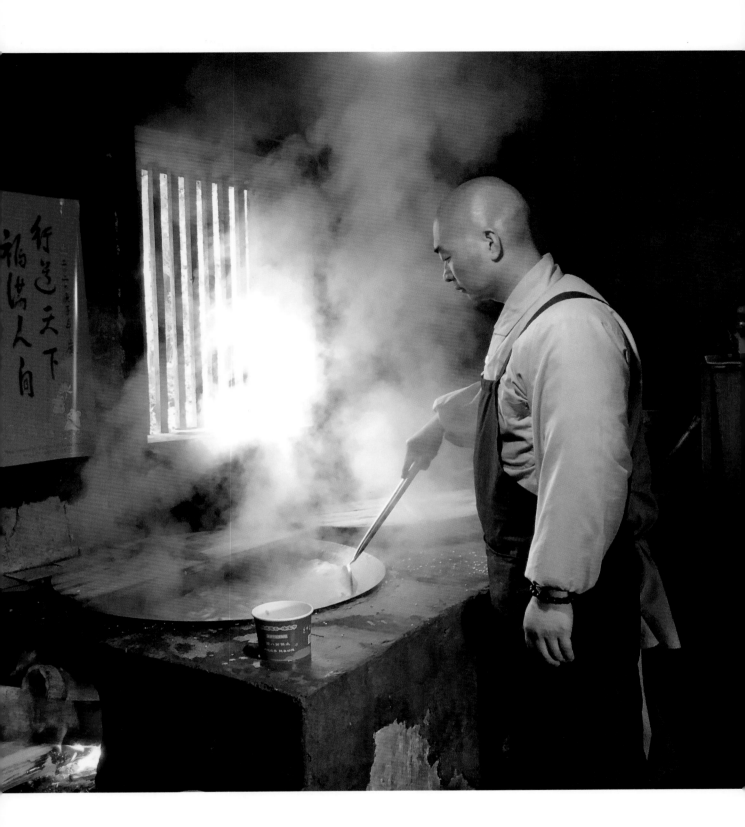

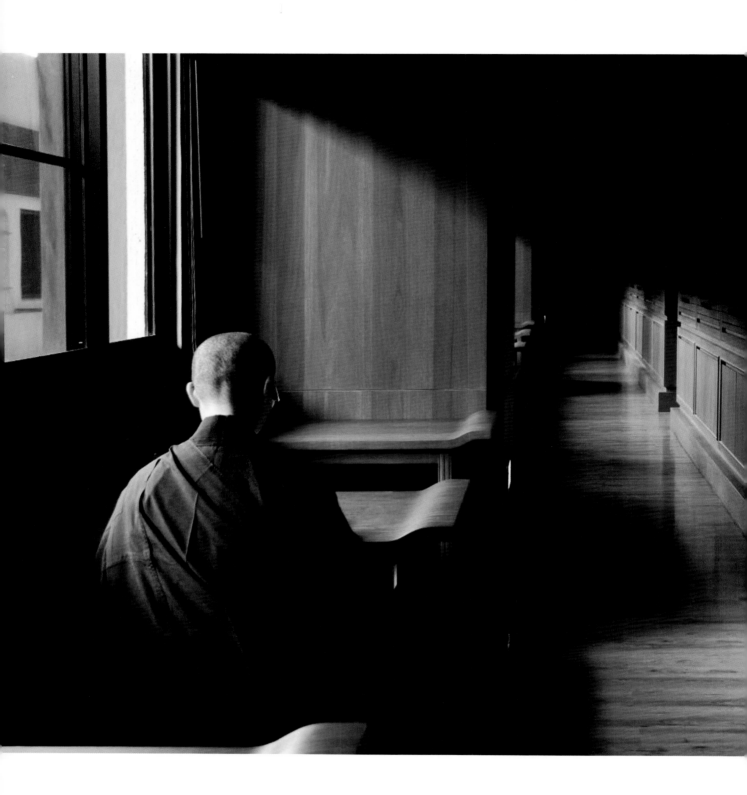

悅讀時光
Time of Pleasure Reading

如地法師｜臺灣／RU DI｜Taiwan

● 2021 攝影類 般若獎
 Photography Prajna Award

簡　歷｜Profile

現於佛光山人間佛教研究院研究中心副主任。曾服務於人間福報社編輯部、開山寮法堂書記一室、首爾佛光山寺等。

Current Deputy Director of the Research Department at FGS Institute of Humanistic Buddhism. She has also previously served at *The Merit Times*, Office of the Founding Master, and Seoul Fo Guang Shan Temple.

創作理念｜Concept

我看我思我拍，用照片留住每個令人感動、最美的時刻。

I observe, I thought, I took. The most moving and beautiful moments are documented by the photos.

別有洞天
Scenery of Exceptional Charm

永有法師 | 臺灣 ／ YUNG YOU | Taiwan

● 2020 攝影類 優選獎
Photography Merit Award

簡 歷 | Profile

現任南華大學生死學系副教授。出家後留學英國,獲倫敦大學宗教學博士。曾任南華大學人間佛教研究推廣中心、學生輔導中心主任及佛學院、社大教師。

Current Associate Professor at Nanhua University. She received a doctor's degree from the University of London. She has served at the Nanhua University, Buddhist College, and Community College.

創作理念 | Concept

以創作展現佛教之美、生命之美。希令見聞者增長對佛法之信心及對生命之熱愛。

Presenting the beauty of Buddhism and life through creation. It is hoped that those who has wisdom will increase their confidence in Buddhism and their love for life.

牽手
Holding Hands

覺印法師 | 臺灣 ／ JUE YIN | Taiwan

● 2020 攝影類 優選獎
 Photography Merit Award

簡 歷 | Profile

現任佛光山佛陀紀念館佛光樓副主任。曾服務於總本山典座監院室雲
居樓、金光明寺、台北道場等。

Currently serving as the Deputy Chief Executive at Buddha Museum. She previously
served at the Cloud Dwelling Building, Jin Guang Ming Temple, Taipei Vihara, etc.

創作理念 | Concept

佛館之美。

The beauty of Buddha Museum.

毫光
Halo

如柏法師 | 臺灣 ／ RU BO | Taiwan

● 2019 攝影類 優選獎
 Photography Merit Award

簡　歷 | Profile

現於總本山司庫室。曾派駐臺灣、香港、菲律賓等地弘法，及服務於
覺世雜誌等。

Currently serving at the Financial Management Office of the FGS. She was previously
stationed in Taiwan, Hong Kong, and the Philippines, and has served at *Awakening
the World magazines*.

創作理念 | Concept

佛國淨土。

The Buddha's Pure Land.

佛光
Buddha's Light

妙宥法師 | 臺灣 ╱ MIAO YOU | Taiwan

● 2019 攝影類 優選獎
Photography Merit Award

簡　歷 | Profile

現任佛光山福山寺住持。曾服務於永和學舍、香海文化事業、總本山
福慧家園、上海普門經舍等。

Currently serving as Abbess of FGS Fu Shan Temple. She has previously served
at Yonghe Temple, Gandha Samudra Culture Company, Fu Hui Home for Spiritual
Cultivation, Shanghai Pu-men Vihara, etc.

創作理念 | Concept

走入花的世界，是清淨，是平等，它莊嚴自己，成就淨土，如同佛子
的心。

Upon entering the world of flowers, one can sense its purity and equality. It solemns
itself and becomes a pure land, just like the mind of Buddha's children.

雲來集
The Great Gathering

依玄法師｜臺灣 ／ YI XUAN｜Taiwan

● 2019 攝影類 優選獎
　Photography Merit Award

簡　歷｜Profile

曾任總本山信眾監院室民眾圖書館組長、都監院書記組長、普門中學
生活老師及於臺灣別分院道場弘法等。

Former Supervisor at the Public Service Department, and the Executive Council,
pastoral teacher at Pu-Men High School and Dharma preacher in Taiwan.

創作理念｜Concept

佛光山之美，在天光雲影、林間夕照，也在遠山交錯與晨昏之間。

The beauty of Fo Guang Shan among sunlight reflections and cloud shadows.
Between the twilight, the mountains are criss-crossed.

神明聯誼

When Buddha meets the Gods Event

永寧法師 | 臺灣 ／ YUNG NING | Taiwan

● 2019 攝影類 優選獎
Photography Merit Award

簡　歷 | Profile

現任美國佛光山西方寺主任。曾於菲律賓佛光山當地道場弘法多年。

Currently serving as the Director of the Hsi Fang Temple in the US. She previously preached in the Philippines for many years.

創作理念 | Concept

以鏡頭捕捉弘法的真善美。

Using the camera to capture the truth, goodness and beauty of Dharma propagation.

佛館之美—花開見佛

The Beauty of Buddha Museum, Seeing the Buddha When the Flower Blooms

妙柔法師 | 臺灣 ╱ MIAO ROU | Taiwan

● 2019 攝影類 優選獎
Photography Merit Award

簡　歷 | Profile

現於佛光山佛陀紀念館五和塔。曾服務於寺務監院室殿堂組、臺北普門寺、美國夏威夷禪淨中心等。

Currently serving at Buddha Museum. She has also served at the Monastery Affairs Department, Taipei Pu-Men Temple, Hawaii Meditation Center, etc.

創作理念 | Concept

在佛館每天開心照顧花草樹木，感覺身處佛國淨土。滿園花開供養佛，美極了！

Happily taking care of the flowers and trees every day in the Buddha Musuem, I feel as if I was in Buddha's pure land. The garden full of flower blossoms as offerings to the Buddha. It's so beautiful!

禪靜回歸自己

Returning of Chan and Calm to Oneself

妙勇法師 | 馬來西亞 ／ MIAO YONG | Malaysia

● 2020 攝影類 優選獎
 Photography Merit Award

簡　歷 | Profile

現於馬來西亞佛光山東禪寺。曾服務於澳洲南天寺、佛光山文教基金會等。

Currently serving at the FGS Dong Zen Temple in Malaysia. She has previously served at the Nan Tien Temple and the FGS Foundation for Buddhist Culture & Education.

創作理念 | Concept

佛教文化是人類心靈的淨土。希望以影像傳達一種寧靜、自在與祥和的境界。

Buddhist culture is the pure land in human spirit. The image hopes to convey realms of tranquility, comfort, and harmony.

雲霧繚繞的如來一代時教廣場

Mist Wreached the Tathagata Lifetime Teaching Square

妙岳法師｜馬來西亞 ／ MIAO YUE｜Malaysia

● 2019 攝影類 優選獎
　Photography Merit Award

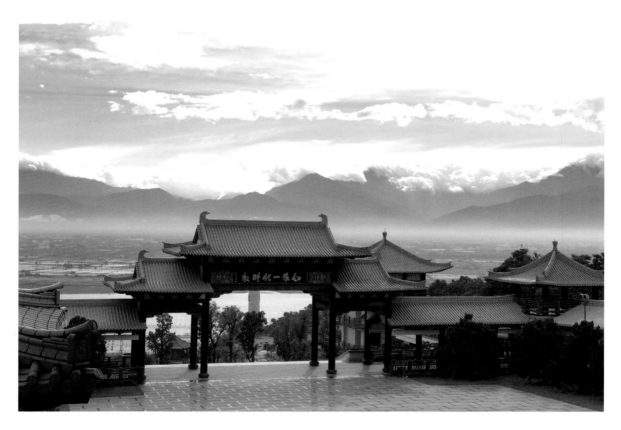

簡　歷｜Profile

現於馬來西亞佛光山檳城佛光學舍。曾派駐於美國佛光山西來寺與總本山寺務監院室殿堂組。

Currently serving at FGS in Penang, Malaysia. He was previously dispatched to Hsilai Temple and the FGS Monastery Affairs Department.

創作理念｜Concept

主要以拍攝寺院景觀、佛像等為主。希望可以拍出寺院之美。

Mainly focused on photos of the temple scenery, Buddha statues, and such, in hopes of capturing the beauty of temple.

日出 · 初照

Sunrise - Initial Illumination

妙護法師｜臺灣 ／ MIAO HU｜Taiwan

● 2019 攝影類 優選獎
Photography Merit Award

簡　歷｜Profile

現任人間福報社編輯。曾服務於佛光山大明寺、均頭國民中小學、桃園講堂等。

Currently serving as Editor of *The Merit Times*. She has served at the Da Ming Temple, Lun Tou Elementary and Junior High School, the Taoyuan Lecture Hall, etc.

創作理念｜Concept

清晨朝山禮佛，驀然轉身，霞光如華嚴日出初照，喚醒沉睡的眾生。「由心故畫，法性如是」。

To prostrate the Buddha in the early morning, the rays of the morning sun is like the first sunrise in the Avatamsaka Sutra. It is to awaken sleeping sentient beings. "The mind caused the drawing just as the nature of the Dharma."

璀璨佛光

Resplendent Glory of the Buddha

知泉法師｜臺灣 ╱ ZHI QUAN｜Taiwan

● 2019 攝影類 優選獎
 Photography Merit Award

簡　歷｜Profile

現於佛光山人間佛教研究院研究中心。曾任人間通訊社記者、佛光大學佛教學系教學助理等。

Currently serving at the Institute of Humanistic Buddhism. She has also served at Life News Agency, and Fo Guang University.

創作理念｜Concept

透過照片呈現大師給人歡喜與佛光淨土之美，看到慈悲、歡喜與自在。

To present the Master's practice of giving others joy and the beauty of the Buddha light's pure land. Through the photos, you can see compassion, joy and perfect ease.

清淨光
Pure Light

妙斌法師 | 臺灣 ╱ MIAO BIN | Taiwan

● 2019 攝影類 優選獎
Photography Merit Award

簡　歷 | Profile

現於佛光山佛陀紀念館法務處。曾服務於總本山寺務監院室園藝組、普門學報等。

Currently serving at the Buddha Museum. She has served at the Monastery Affairs Department, the *Universal Gate Buddhist Journal*, etc.

創作理念 | Concept

2018 年世界神明聯誼會的清晨,工作人員已各就各位。大佛平台,拍下佛所變現清淨的光明。

In the early morning of the 2018 "When Buddha Meets the Gods Event", the staff were ready in their place.　At the Big Buddha Terrace, I took a picture of the pure light which had appeared by the Buddha.

雨後
After Rain

如地法師 | 臺灣 / RU DI | Taiwan

● 2019 攝影類 優選獎
Photography Merit Award

簡　歷 | Profile

現於佛光山人間佛教研究院研究中心副主任。曾服務於人間福報社編輯部、開山寮法堂書記一室、首爾佛光山寺等。

Currently serving as Deputy Director at the FGS Institute of Humanistic Buddhism. She has also served at *The Merit Times*, Office of the Founding Master, and Seoul Fo Guang Shan Temple.

創作理念 | Concept

雨後陰霾未散，彩虹卻悄然出現，在隱沒前，倏忽地撥雲見日。

After the rain, the haze did not clear, but the rainbow appeared quietly. Before disappearing, every cloud has a silver lining suddenly.

山中，歲月靜好
The Times in the Mountains were Fine and Peaceful

如地法師 | 臺灣 ╱ RU DI | Taiwan

● **2020 攝影類 優選獎**
 Photography Merit Award

創作理念 | Concept

以相機記錄所見美好的事物、感動的瞬間，留下永恆的回憶。

To record all the beautiful and moving things that I have seen with camera, and leave behind eternal memories.

佛教信仰從小扎根

Have Faith in Buddhism from Childhood

妙毓法師｜馬來西亞 ╱ MIAO YU｜Malaysia

● 2019 攝影類 優選獎
　Photography Merit Award

簡　歷｜Profile

現於國際佛光會世界總會亞洲辦事處。曾服務於國際佛光會世界總會
亞洲總部。

Current BLIA Asia Regional Office of BLIA World Headquarters. She has also served
at BLIA Asia Headquarters.

創作理念｜Concept

珍貴的畫面，是信仰的足跡與修行的體悟。
佛教信仰的傳承需從小扎根。

The precious picture is a footprint of faith and recognition of spiritual practice. The
inheritance of Buddhist beliefs needs to take root from an early age.

童趣
Children's Delight

妙旭法師 | 臺灣 ╱ MIAO XU | Taiwan

● 2020 攝影類 優選獎
　　Photography Merit Award

簡　歷 | Profile

現任佛光山普門寺監寺，曾服務於台北道場、佛光人間大學、佛光山百萬人興學委員會、佛光祖庭大覺寺等。

Current Superintendent at Pu Men Vihara. She has previously served at Taipei Vihara, Buddha's Light Open University, FGS Million-Member Fundraising Committee, and Dajue Temple in Yixing, etc.

創作理念 | Concept

小朋友於佛館自在歡快，展現無拘的本性，留下快樂的童年記憶。

Children in the Buddha Museum are happy and cheerful, showing their unrestrained nature while creating their happy childhood memories.

藥師光如來
Medicine Buddha

如禎法師 | 馬來西亞 ／ RU ZHEN | Malaysia

● 2019 攝影類 優選獎
Photography Merit Award

簡　歷 | Profile

現於佛光山台北道場。曾服務於馬來西亞
佛光山東禪寺、澳洲南天寺、佛光山文教
基金會等。

Currently serving at the FGS Dong Zen Temple
in Malaysia. She has previously served at the Nan
Tien Temple and the FGS Foundation for Buddhist
Culture & Education.

創作理念 | Concept

佛教文化是人類心靈的淨土。希望以影像
傳達一種寧靜、自在與祥和的境界。

Buddhist culture is the pure land in human spirit.
The image hopes to convey realms of tranquility,
comfort, and harmony.

眾神雲集
Gods Gathered

知輝法師｜臺灣／ ZHI HUI｜Taiwan

● 2020 攝影類 優選獎
　　Photography Merit Award

簡　歷｜Profile

現於女眾禪學堂，前後參與佛光大藏經史傳藏與聲聞藏編輯組。

Currently serving at the Women's Meditation College. She has also participated intermittently in the Editorial Unit of the Biographical and Sravaka Canons.

創作理念｜Concept

一年一次神明聯誼，眾神皆來佛館朝聖。

The annual "When Buddha Meets the Gods Event" where all the gods gather at the Buddha Museum for pilgrimage.

花開見佛

Seeing the Buddha When the Flower Blooms

知持法師 | 臺灣 ／ ZHI CHI | Taiwan

● 2019 攝影類 優選獎
Photography Merit Award

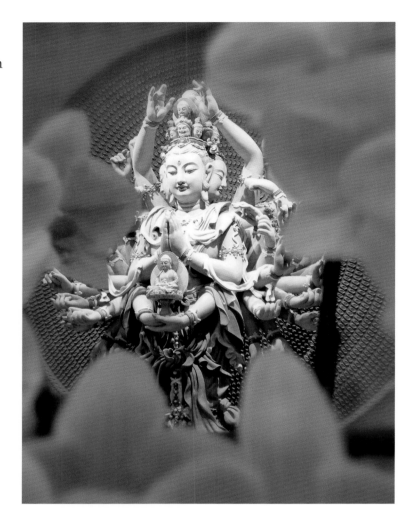

簡　歷 | Profile

現於日本佛光山本栖寺。曾服務於南屏別院、南台別院等。

Currently serving at Motosu Temple, Japan. She has served at Nan Ping Temple and Nan Tai Temple.

創作理念 | Concept

「心如工匠師，能畫諸世間。」希望以鏡頭拍下寺院的靜與美，捕捉修行人的心境。

"The mind is like a painter who can paint the world." Hope to capture the tranquility and beauty of the temple with the lens and capture the mind of the practitioner.

共生共榮
Coexistence and Shared Glory

知斌法師｜臺灣／ZHI BIN｜Taiwan

● 2019 攝影類 優選獎
　Photography Merit Award

簡　歷｜Profile

現為開山寮侍者。曾服務於女眾傳燈會。

Currently serving as Attendant at the Residence of the Founding Master. She has also served at the Sangha Affairs Committee.

創作理念｜Concept

希望看見人間善美的一面。

Hope to see the good and beauty of humanity.

自在一如
Perfect At Ease as One

如全法師 | 印度 ╱ RU QUAN | India

● 2019 攝影類 優選獎
 Photography Merit Award

簡 歷 | Profile

現任新加坡佛光山法務組組長。曾服務於佛光山加爾各答禪淨中心等。

Currently serving as Supervisor at Fo Guang Shan Singapore. She has also served at FGS Calcutta Buddhist Centre, etc.

創作理念 | Concept

在鏡頭下，看到人間風景。好與壞都將過去，一如昨日的足跡與晚霞，終將隨風消逝。

Under the lens, I saw human scenery. The good and the bad, both will pass, just like yesterday's footprints and sunset that have gone with the wind eventually.

隨緣自在樂在其中

Adhere to Conditions with Perfect Ease and Happiness from Within

知泉法師｜臺灣／ ZHI QUAN｜Taiwan

● 2020 攝影類 優選獎
　Photography Merit Award

簡　歷｜Profile

現於佛光山人間佛教研究院研究中心。曾任人間通訊社記者、佛光大
學佛教學系教學助理等。

Currently serving at Institute of Humanistic Buddhism. She has also served at Life
News Agency, and Fo Guang University.

創作理念｜Concept

透過鏡頭拍攝人間的真善美。

To captured the truth, goodness, and beauty of the world with the camera.

幸福

Happiness

黃進寶教士｜馬來西亞 ／ NG CHIN POH｜Malaysia

● 2020 攝影類 優選獎
 Photography Merit Award

簡　歷｜Profile

現於印度佛光山德里文教中心、印度德里沙彌學園。曾派
駐馬來西亞、多倫多、臺灣等別分院道場。

Currently serving at New Delhi Educational & Cultural Centre, Delhi
Sramanera College, India. He was previously stationed at FGS branch
temples in Malaysia, Toronto and Taiwan.

創作理念｜Concept

佛法需「解行並重」。聽課是「解門」；出坡是「行門」。
沙彌們在教室用功理「解」，在灑掃中歡喜「行」佛。

Dharma requires "equal emphasis on practice and understanding."
Attending a class is to "teach in theory" and doing chorework is to
"teach in practice.".

人間佛教的傳承
Legacy of Humanistic Buddhism

王桂卿師姑 | 馬來西亞 ╱ ONG KWI KENG | Malaysia

● 2019 攝影類 優選獎
 Photography Merit Award

簡 歷 | Profile

現任馬來西亞佛光出版社副執行長。曾服務於馬來西亞佛光山東禪寺、東禪佛教學院月刊主編。

Currently serving as Deputy Chief Executive of Fo Guang Publishing, Malaysia. She has served at the FGS Dong Zen Temple, and *FGS Education Monthly Magazine*.

創作理念 | Concept

將真善美的畫面，定格永存。

Freezing the frame to preserve the image of truth, goodness, and beauty forever.

願
Wish

慧融法師｜臺灣 ／ HUI RONG｜Taiwan

● 2021 攝影類 優選獎
　Photography Merit Award

簡　歷｜Profile

現任總本山寺務監院室監院。熟稔法務梵唄唱誦。曾任佛光山叢林學院男眾學部總務長等職。

Current Department Head of Monastery Affair. He is familiar with Dharma services and hymn. He has previously served at FGS Tsung Lin University.

創作理念｜Concept

將生活中的佛法以影像紀錄下來並傳達給有緣人。

Recording the Dharma in our life with images and conveying them to those who have affinity.

眉際玉毫光燦爛

Glorious Urnalaksana

妙頌法師｜臺灣 ／ MIAO SONG｜Taiwan

● 2021 攝影類 優選獎
Photography Merit Award

簡　歷｜Profile

現任佛光山南屏別院監院。熟稔法務行政、梵唄唱誦。曾任台北道場。

Current Department Head at Nan Ping Temple. She is familiar with Dharma services and hymn. SHe has previously served at Taipei Vihara.

創作理念｜Concept

用虔誠恭敬的心，於每次法會活動莊嚴壇場，在人間菩薩修行道場，願將佛法的美好、意涵，含融於生活之中，以佛法之美供養禮敬未來一切諸佛。

With a devout heart, I solemnly dignified Dharma's every event where Humanistic Buddhism is practiced. May the beauty and meaning of Dharma merge into our daily lives and we make offerings to all Buddhas with the beauty of the Dharma.

龜山島之美－日出倒影

The beauty of Guishan Island - Reflection of Sunrise

妙坤法師｜臺灣 ╱ MIAO KUEN｜Taiwan

● 2021 攝影類 優選獎
Photography Merit Award

簡　歷｜Profile

現任於佛光大藏經編藏處。曾於佛光山惠中寺、普門寺及數十年於文化單位從事編輯等。

Currently serving at the Buddhist Canon Research Department. She has previously served at Hui Chung Temple, Pu Men Vihara, and has been an editor for decades.

創作理念｜Concept

體現佛教在人間，處處真善美人間。

Manifestation of Buddhism, the truth, virtue, and beauty in the human world.

自在解脫
At Ease and Liberated

依日法師｜臺灣／YI JIH｜Taiwan

● 2021 攝影類 優選獎
Photography Merit Award

簡　歷｜Profile

曾任於佛光山叢林學院教務處教學組長、普賢寺住持、福山寺住持、三寶寺弘講師、國際佛教促進會辦公室主任等。

Former Supervisor at the Office of Academic Affairs in FGS Tsung Lin University. Previously served at Pu Hsien Temple, Fu Shan Temple, San Bao Temple, and International Buddhist Progress Society.

創作理念｜Concept

一日經過佛光山寺藍毗尼園，在靠近鐘樓轉角，看到這尊躺臥著的沙彌，顯得自在解脫，便隨手按下。

As I was passing by the Fo Guang Shan Lumbini Garden one day under the bell tower, there lies a carefree novice statue. Therefore, I took this picture.

心光

Light of Heart

如輝法師 | 臺灣 ╱ RU HUI | Taiwan

● 2021 攝影類 優選獎
Photography Merit Award

簡　歷 | Profile

現任佛光山文教基金會辦公室主任。曾任佛光山佛陀紀念館電子媒體組組長、臺中光明學苑主任，及於人間大學、金光明寺等地服務。

Currently serving at FGS Foundation for Buddhist Culture and Education. She has previously served at Buddha Museum, Guang Ming Learning Center, FGS Open University, and Jing Kuang Ming Temple, etc.

創作理念 | Concept

晨光照破黑夜，朝陽爬上綠葉的肩；讓薄如蟬翼的心葉，赤裸透亮熠熠生輝；亦如明亮的心光，願我心如光；遍照大地　溫暖人間。

Dawn shines on the darkness of the night and its rays invades the green leaves. The sparkling shine on the interior leaves as thin as a cicada's wings manifests a bare, bright heart. May my heart be bright and there is warmth all over the world.

影音類
Audiovisual

黑鼻觀音
慈悲絲路
聰敏靈巧

Black Nose Avalokitesvara
Compassion of the Silk Road
Be Smart and Agile

道璞法師 ｜ 臺灣 ／ DAO PU ｜ Taiwan

● 2017 動漫類 佛光獎
　　Anime Fo Guang Award

簡　歷 ｜ Profile

現任開山寮法堂書記二室書記，擅長繪畫。
曾服務於佛光大藏經編藏處，早期受派駐
日本弘法並學習漫畫創作。

Currently serving at the Residence of the
Founding Master. Skillful at painting, she has
previously served at the Buddhist Canon Research
Department and was dispatched to Japan in the
early period.

創作理念 ｜ Concept

星雲大師《星雲說喻》的故事透過漫畫表現，
希望大眾將故事中的智慧運用在生活中。

To manifest the stories of *Hsing Yun's Parables* through
comics, and hope the viewers practice the wisdom of
the stories in their daily lives.

黑鼻觀音

文／星雲大師　　繪／道璞法師

菩薩的鼻子
為什麼是黑的呢？

電腦繪圖
Computer Graphics

播放檔

在師父身邊的日子
Days by Master's Side

妙至法師｜臺灣 ／ MIAO ZHI｜Taiwan

● 2020 影音類 佛光獎
 Audiovisual Fo Guang Award

2020.03.16~03.29
在師父身邊的日子
第九期佛光山徒眾人間佛教短期研究班

簡　歷｜Profile

現任佛光山佛陀紀念館大覺堂主任。曾服務於電視中心等。

Currently serving as Deputy Executive at the Buddha Museum. She has also served at FGS TV Center among others.

創作理念｜Concept

感謝師父上人為弟子們蓋藏經樓，在這裡參與短期研究班學習，就好像「在師父身邊的日子」以法與師父接心。

Truly appreciate the Master for building the Sutra Repository for the disciples where I was able to participate in the short-term seminar. It's like "the days with the Master" being able to connect heart-to-heart with the Master through Dharma.

影片
Film

3 分鐘

悟 · 一念之間

Enlightenment - All in a Moment of Thought

知明法師｜紐西蘭／ ZHI MING｜New Zealand

● 2021 影音類 佛光獎
 Audiovisual Fo Guang Award

簡　歷｜Profile

現任佛光山普賢寺。曾服務於佛陀紀念館、總本山修持監院室女眾禪學堂及派駐紐西蘭弘法等。

Currently serving at Pu Hsien Temple. She has also served at Buddha Museum, Women's Meditation College, dispatched to New Zealand, etc.

創作理念｜Concept

為了表達及呈現師父的理念，讓大家有機會和興趣來認識人間佛教。尤其現在的小朋友及年輕人，都是新 Z 時代的人，對於動畫特效、聲音等新媒體比較感興趣。透過這種方式，就可以潛移默化（播下種子，熏習法益），讓大家慢慢了解佛法，接受佛教。

Expressing the Master's philosophy to everyone who has the opportunity and interest to learn about Humanistice Buddhism, especially designed for the new Z generation who are more interested in animation and sound. They can gradually understand the Dharma and accept Buddhism through the new media.

影片
Film

2 分 27 秒

信仰連接

The Connection of Faith

知居法師｜臺灣 ／ ZHI JU｜Taiwan

● 2020 影音類 菩提獎
Audiovisual Bodhi Award

簡　歷｜Profile

現於女眾傳燈會醫療組。曾服務於佛光山佛陀紀念館展覽處。

Currently serving at the Sangha Affairs Committee. She has also served at the Exhibition Division of Buddha Museum.

創作理念｜Concept

師父上人的慈心悲願而建設新寶橋，方便信眾往來大悲殿禮拜觀世音菩薩。工程期間不定時去攝影留下影像紀錄。

The Master's loving heart and compassionate vow to build a new Treasure Bridge for the purpose of enabling devotees to visit the Great Compassion Shrine and prostrate to the Avalokitesvara Bodhisattva. During the construction period, I went to take pictures for documentation from time to time.

影片
Film

2 分 26 秒

簡單的心
Simple Mind

能超法師｜臺灣 ╱ NENG CHAO｜Taiwan

● 2021 影音類 菩提獎
　　Audiovisual Bodhi Award

簡　歷｜Profile

就讀於佛光山叢林學院女眾學部－經論教理系。

Currently studying at FGS Tsung Lin University Women's Buddhist College, Department of Sutras and Doctrine.

創作理念｜Concept

學院的生活，樸實簡單，放下世俗的塵勞，看見最初的自己，成為一杯能容納止回閥誰的空杯，一雙羅漢鞋就能帶我走很遠，一顆簡單的心。

One's initial self and letting go of the secular affliction can be seen in the simple university life. Becoming an empty cup that can fit the capacity of a back pressure valve, a pair of arhat shoes with a simple mind can take me far away.

影片
Film

1 分 56 秒

人間佛國—佛光山之美

Buddha Land in the Human World-
The Beauty of Fo Guang Shan

道璞法師 | 臺灣 ／ DAO PU | Taiwan

● 2018 動漫影音類 般若獎
　　Anime Video Prajna Award

簡　歷 | Profile

現任開山寮法堂書記二室書記，擅長繪畫。曾服務於佛光
大藏經編藏處，早期受派駐日本弘法並學習漫畫創作。

Currently serving at the Residence of the Founding Master.　Skillful at
painting, she has previously served at the Buddhist Canon Research
Department and was dispatched to Japan in the early period.

影片
Film

4 分 07 秒

創作理念 | Concept

剪輯佛光山 2017 年 7 月至 2018 年 6 月之間所拍攝錄影的
大自然之美，分享佛光淨土之美好！

The beauty of nature in Fo Guang Shan edited from July 2017 to June
2018 with intent to share the beauty of the Buddha Light's Pure Land!

堅持的力量
Strength of Persistence

乘銘沙彌｜印度 ╱ CHENG MING｜India

● 2020 影音類 般若獎
Audiovisual Prajna Award

簡　歷｜Profile

現就讀於佛光大學。曾就讀於印度佛光山德里沙彌學園。

Student of Fo Guang University. Former student of Delhi Sramanera College, India.

創作理念｜Concept

沙彌學園裡的武術集訓，過程中難免筋疲力盡不想繼續練習。老師鼓勵我們要「再」堅持一下，定能達到目標。

It was inevitable that I became exhausted and no longer wish to continue practicing martial arts training at the Sramanera College. The instructor encouraged us to have a little more persistence to achieve our goals.

影片
Film

3 分 36 秒

博物館之旅
Tour of Museum

妙至法師 | 臺灣 ╱ MIAO ZHI | Taiwan

● 2021 影音類 般若獎
　Audiovisual Prajna Award

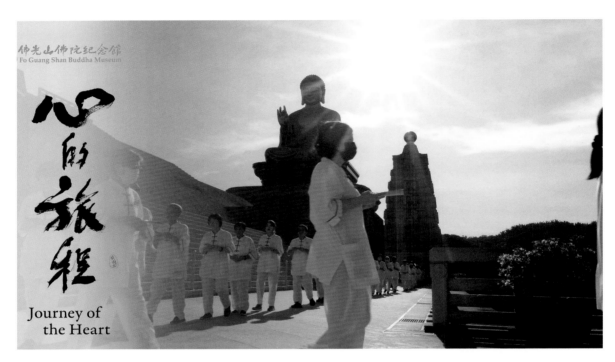

簡　歷 | Profile

現任佛光山佛陀紀念館大覺堂主任。曾服務於電視中心等。

Currently serving as Deputy Executive at the Buddha Museum. She has also served at FGS TV Center among others.

創作理念 | Concept

為讓忙碌的現代人能有兩天一夜的時間可以放慢腳步、靜下心來體驗佛門生活，甚至可以夜宿博物館，佛館推出心的旅程活動。整理 2019 至今的拍攝片段，剪輯為心的旅程 2 分 15 秒的宣傳影片，希望能讓更多人知道此活動訊息，進而認識佛教。

The Buddha Musem launched "Journey of the Heart" event for the busy modern people who can stay two days at the museum to slow down and experience Buddhist life. This short promotional film is edited for the event from 2019 to the present. Hope more people knows about this event and learn more about Buddhism from it.

影片
Film

2 分 15 秒

本的攝影集
Ben's Photography Collection

有本法師｜臺灣／YOU BEN｜Taiwan

● 2020 影音類 優選獎
Audiovisual Merit Award

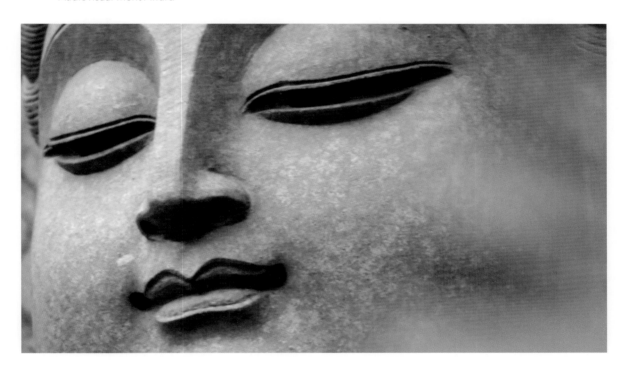

簡　歷｜Profile

現於佛光山寶塔寺。曾服務於慧慈寺、蘭陽別院、福山寺、佛光緣美術館彰化館。

Currently serving at Bao Ta Temple. She has previously served at Hui Chi Temple, Lanyang Temple, Fu Shan Temple, and Changhua Fo Guang Yuan Art Gallery.

影片
Film

1 分 07 秒

創作理念｜Concept

一生中或許就只有那麼一次⋯
所以喜歡將走過的景點，用影像作為紀念，每張照片都是美好的回憶。

Maybe only once in a lifetime...
I like to take photos as commemorations of the scenic spots wherever I go. Every photo is a wonderful memory.

明心見性的那碗粥
Porridge of Conscious

有容法師 | 臺灣 / YOU RONG | Taiwan

● 2021 影音類 優選獎
　 Audiovisual Merit Award

簡　歷 | Profile

現任國際佛光會中華總會副祕書長。曾任國際佛光會世界
總會亞洲辦事處辦公室主任、人間福報中區辦公室主任等。

Currently serving as Deputy Secretary General of BLIA Chunghua
Headquarters. She has previously served at the BLIA Asia Regional
Office and *The Merit Times*.

影片
Film

50 秒

創作理念 | Concept

以影片方式將「臘八粥」的烹調方式紀錄下來，分享給更
多人學習如何烹調出好吃的臘八粥，將師父的人間佛教精
神持續傳遞出去。（2020 年修學護照之典座研習課程）。

Filming the cooking method of "Laba Congee," and sharing it with
people on how to cook delicious congee, while passing along the
spirit of Master's Humanistic Buddhism. (2020 Temple Chef Course).

佛光緣美術館出版系列
Fo Guang Yuan Art Gallery Book Series

藝術生活化，生活藝術化
將美術館延伸到您的生活空間
細細品味，真心收藏
歡迎把藝術的美好帶回家

Art being life-oriented, everyday living transformed into art
Let the art gallery extend into your living space
Savor it and put it into your collection
Please bring the goodness of art back home

● **典藏作品集系列** *Collection of Work Series*

● 展出作品集系列 *Exhibition Series*

● 一筆字系列
One Stroke Calligraphy Work Series

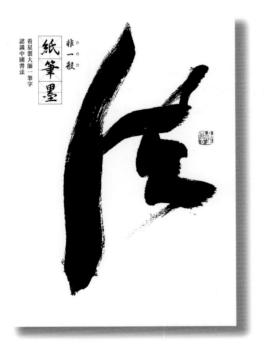

● 佛光山佛陀紀念館叢書系列 *Buddha Museum Collection Series*

更多的紀念品可上網查詢 For more souvenirs, please visit our online store

● 佛光山佛陀紀念館　https://www.fgsbmc.org.tw/tw/index.aspx　07-6561921 分機 4247
● 佛光緣美術館　http://fgsarts.fgs.org.tw/　07-6561921 分機 1433

佛光緣美術館台灣及全球各洲分館據點
Taiwan and Worldwide Branches of Fo Guang Yuan Art Gallery

佛光緣美術館總部
Fo Guang Yuan Art Gallery Headquarters
Addr: 840 高雄市大樹區佛光山寺
Tel: +886-(7)-6561921 Ext. 1434–1438　Fax: +886-(7)-6565196
E-mail: fgs_arts@ecp.fgs.org.tw

佛光山佛陀紀念館展覽廳
Fo Guang Shan Buddha Memorial Center
Addr: 840 高雄市大樹區統嶺里統嶺路 1 號
Tel: +886-(7)-6561921 Ext. 4247　Fax: +886-(7)-6564781
E-mail: mhadmin@ecp.fgs.org.tw

佛光山寺 / 總館
Fo Guang Yuan Main Art Gallery
Addr: 840 高雄市大樹區佛光山寺
Tel: +886-(7)-6561921 Ext. 1430　Fax: +886-(7)-6565196
E-mail: fgs_arts2@ecp.fgs.org.tw

佛光山屏東講堂 / 屏東館
Fo Guang Yuan Pingtung Art Gallery
Addr: 900 屏東市建華三街 46 號 3 樓
Tel: +886-(8)-7512608 Ext. 301　Fax: +886-(8)-7529879
E-mail: fgs_arts5@ecp.fgs.org.tw

佛光山南屏別院 / 高雄館
Fo Guang Yuan Kaohsiung Art Gallery
Addr: 813 高雄市左營區忠言路 28 號 6 樓
Tel: +886-(7)-5562092　Fax: +886-(7)-5560743
E-mail: fgs_arts8@ecp.fgs.org.tw

佛光山南台別院 / 台南館
Fo Guang Yuan Tainan Art Gallery
Addr: 708 台南市永華路二段 161 號 5 樓
Tel: +886-(6)-2932777 Ext. 1105　Fax: +886-(6)-2934279
E-mail: fgs_arts9@ecp.fgs.org.tw

佛光山福山寺 / 彰化館
Fo Guang Yuan Changhua Art Gallery
Addr: 500 彰化市福山里福山街 348 號
Tel: +886-(4)-7322571　Fax: +886-(4)-7386348
E-mail: fgs_arts7@ecp.fgs.org.tw

佛光山惠中寺 / 台中館
Fo Guang Yuan Taichung Art Gallery
Addr: 408 台中市南屯區惠中路三段 65 號
Tel: +886-(4)-22520375　Fax: +886-(4)-22519950
E-mail: fgs_arts10@ecp.fgs.org.tw

佛光山台北道場 / 台北館
Fo Guang Yuan Taipei Art Gallery
Addr: 110 台北市松隆路 327 號 10 樓之 1
Tel: +886-(2)-27600222　Fax: +886-(2)-27694988
E-mail: fgs_arts3@ecp.fgs.org.tw

佛光山蘭陽別院 / 宜蘭館
Fo Guang Yuan Yilan Art Gallery
Addr: 260 宜蘭市中山路三段 257 號 4 樓
Tel: +886-(3)-9310333　Fax: +886-(3)-9330330
E-mail: fgs_arts6@ecp.fgs.org.tw

中國大陸佛光祖庭大覺寺 / 大覺分館
Yixing Dajue Temple Art Gallery
Addr: 江蘇省宜興市西渚鎮香林路 66 號　郵編 214236
Tel: +86-(510)-87376181、8737-6182　Fax: +86-510-8737-6185
E-mail: fgs_arts11@ecp.fgs.org.tw

中國大陸嘉應會館美術館
Jiaying Huiguan Art Gallery
Addr: 中國江蘇省蘇州市姑蘇區閶胥路一號　郵編：215004
Tel: +86-(512)-68362746
E-mail: fgs_arts12@ecp.fgs.org.tw / jiayinghg@sina.com

中國大陸鑑真圖書館美術館
Jianzhen Library Art Gallery
Addr: 中國江蘇省揚州市邗江區鑑真路 1 號　郵編:225007
Tel: +86-(514)-80983750　Fax: +86-(514)-87755322
E-mail: fgs_arts13@ecp.fgs.org.tw / yzforum2008@yahoo.com

中國大陸上海星雲文教館美術館
Hsing Yun Culture and Education Center Art Gallery
Addr: 上海閔行區中春路 9966 弄 62 號
Tel: +86-(21)-38618168
E-mail: fgs_arts24@ecp.fgs.org.tw

佛光緣美術館台灣及全球各洲分館據點
Lntroduction to Taiwan and Worldwide Continental Branches of Fo Guang Yuan Art Gallery

中國大陸南京天隆寺美術館
Nanjing Tianlong Temple Art Gallery
Addr：江蘇省南京市雨花台區南京軟件谷軟件大道 119 號
TEL：+86-(025)-86386699

香港佛光道場 / 香港館
Fo Guang Yuan Hong Kong Art Gallery
Addr: 香港九龍灣宏光道 1 號億京中心 16 樓 B 座
Tel: +852-31109000　Fax: +852-31109025
E-mail: fgs_arts20@ecp.fgs.org.tw

馬來西亞佛光山東禪寺 / 東禪館
Fo Guang Yuan Dong Zen Art Gallery
Addr: PT2297, Jalan Sg. Buaya, 42600 Jenjarom, Kuala Langat, Selangor, Malaysia
Tel: +60-(3)-31911533　Fax: +60-(3)-31911467
E-mail: fgs_arts17@ecp.fgs.org.tw

菲律賓佛光山萬年寺 / 馬尼拉館
Fo Guang Yuan Manila Art Gallery
Addr: 656 Pablo Ocampo St, Malate, Manila,1004 Metro Manila, Philippine.
Tel: +63-(2)-85234909　Fax: +63-(2)-5221475
E-mail: fgs_arts21@ecp.fgs.org.tw

美國佛光山西來寺 / 西來館
Fo Guang Yuan Hsi Lai Art Gallery
Addr: 3456 S. Glenmark Drive, Hacienda Heights, CA 91745 USA
Tel: +1-(626)-9619697　Fax: +1-(626)-3691944
E-mail: fgs_arts14@ecp.fgs.org.tw

澳洲佛光山南天寺 / 南天館
Fo Guang Yuan Nan Tien Art Gallery
Addr: 180 Berkeley Rd., Berkeley, NSW 2506 Australia
Tel: +61-(2)-42720600　Fax: +61-(2)-42720601
E-mail: fgs_arts15@ecp.fgs.org.tw

紐西蘭北島佛光山 / 紐西蘭一館
Fo Guang Yuan IBT New Zealand Art Gallery
Addr: 16 Stancombe Road, Flat Bush, Manukau 2016 New Zealand
Tel: +64-(9)-2744880　Fax: +64-(9)-2744550
E-mail: fgs_arts18@ecp.fgs.org.tw / nzfgs1@gmail.com

紐西蘭南島佛光山 / 紐西蘭二館
Fo Guang Yuan IBA New Zealand Art Gallery
Addr: 2 Harakeke St., Riccarton, Christchurch 8011, New Zealand
Tel: +64-(3)-3416276 Fax: +64-(3)-3416294
E-mail: fgs_arts19@ecp.fgs.org.tw / nzfgs2@gmail.com

法國佛光山法華禪寺 / 巴黎館
Fo Guang Yuan Paris Art Gallery
Addr: 3 allée Madame de Montespan, 77600 Bussy Saint Georges, France
TEL: +33(0)1-60213636
E-mail: fgs_arts23@ecp.fgs.org.tw

馬來西亞佛光山新馬寺 / 新馬館
Fo Guang Yuan Hsingma Art Gallery
Addr:Lot111561, Taman Sutera Utama,81300 Mukim Pulai, Dearah, Johor Bahru
TEL: +603-31911533
E-mail: fgshsingma@gmail.com

日本佛光山法水寺 / 日本館
Fo Guang Yuan Housuiji Japan Art Gallery
Addr：〒 377-0102 群馬縣澀川市伊香保町伊香保 637-43
TEL：+81-279722401
E-mail：gunnma@ecp.fgs.org.tw

泰國佛光山泰華寺 / 泰國館
Fo Guang Yuan Thai Art Gallery
Addr：Kubon Road (Opposite Soi Kubon 34) Bangchan Klongsamwa Bangkok 10510 Thailand
TEL：+66-(2)-9494731
E-mail：fgsthaihua@gmail.com

非洲佛光山南華寺 / 南非館
Fo Guang Yuan South African Art Gallery
Addr：27 Nan Hua Road, Cultural Park, Bronkhorstspruit 1020 South Africa
TEL：+27-(13)-9310009
E-mail：info@nanhua.co.za

國家圖書館出版品預行編目 (CIP) 資料

佛光之美：佛光山法師、師姑創作作品集 2017-2021 = Beauty of
Buddha's light : art by members of Fo Guang Shan monastic order
2017-2021 / 釋如常主編. -- 高雄市：財團法人佛光山文教基金會
出版：佛光緣美術館總部發行, 2022.6
　　面；　公分
中英對照
ISBN 978-957-457-598-5(平裝)

1. 佛教美術 2. 繪畫 3. 畫冊

224.52　　　　　　　　　　　　　　110017288

佛光之美─
佛光山法師、師姑創作作品集
(*2017-2021*)

主　　編：如常法師
執行編輯：知建法師
中文編輯：如川法師
校　　對：佛光山傳燈會
英文翻譯：王玉梅
英文校對：Annie Yang
美術設計：有欣法師
攝　　影：薛湧

出　　版：財團法人佛光山文教基金會
發　　行：佛光緣美術館總部

地　　址：84010 高雄縣大樹鄉佛光山寺
電　　話：886-7-656-1921 轉 1433
傳　　真：886-7-656-5196
E - m a i l：fgs_arts@fgs.org.tw
網　　址：http://www.fgs.org.tw/fgsart
出　　版：2022 年 6 月
訂　　價：600 元〈台幣〉

Beauty of Buddha's Light ─
Art by Members of Fo Guang Shan Monastic Order
2017-2021

Chief Editor: Venerable Ru Chang
Executive Editor: Venerable Zhi Jian
Editor: Venerable Ru Chuan
Proofreader: Fo Guang Shan Light Transmission Council
English Translator: Mia Wong
English Proofreader: Annie Yang
Art Designer: Venerable You xin
Photographer: Hsueh Yung

Publisher: Fo Guang Shan Foundation for Buddhist Culture & Education
Distributor: Fo Guang Yuan Art Gallery

Address: Fo Guang Shan, No. 153, Xingtian Road, Dashu District,
　　　　　　Kaohsiung City, Taiwan 84049 Tel / 886-7-656-1921 Ext. 1433
Fax: 886-7-656-5196
Website: http://fgsarts.fgs.org.tw
E-mail: fgs_arts@ecp.fgs.org.tw
Published Date: Jun 2022
Price: NT$600
ISBN: 978-957-457-598-5